General Editor
David Piper

Toulouse-Lautrec
Every Painting I

M. G. Dortu and J. A. Méric

Introduction translated by Hilary E. Paddon

Captions translated by Catherine Atthill

RIZZOLI
NEW YORK

Foreword by the General Editor

Several factors have made possible the phenomenal surge of interest in art in the twentieth century: notably the growth of museums, the increase of leisure, the speed and relative ease of modern travel, and not least the extraordinary expansion and refinement of techniques of reproduction of works of art, from the ubiquitous colour postcards, cheap popular books of colour plates, to film and television. A basic need – for the general art public, as for specialized students, academic libraries, the art trade – is for accessible, reliable, comprehensive accounts of the works of the individual great masters of painting; this has not been met since the demise before 1939 of the famous German series, *Klassiker der Kunst*; when such accounts do appear, in the shape of full *catalogues raisonnés*, they are vast in price as in size, and beyond the reach of most individual pockets and the capacity of most private bookshelves.

The aim of the present series is to provide an up-to-date equivalent of the *Klassiker* for the now enormously enlarged public interested in art. Each volume (or volumes, where the quantity of work to be reproduced cannot be contained in a single one) catalogues and illustrates chronologically the complete paintings of the artist concerned. The catalogues reflect as far as possible a consensus of current expert opinion about the status of each picture; in the nature of things, consensus has yet to be reached on many points, and no one professionally involved in the study of art-history would ever be so rash as to claim definitiveness. Within the bounds of human fallibility, however, every effort has been made to achieve both comprehensiveness and factual accuracy, while the quality of reproduction aimed at is the highest possible in this price range, and includes, of course, colour. Every effort has also been made to hold the price down to the lowest possible level, so that these volumes may stay within the reach not only of libraries, but of the individual student and lover of great painting, so that they may gradually accumulate their own 'Museum without Walls'. The introductions, written by acknowledged authorities, summarize the life and works of the artists, while the illustrations place in perspective the complete story of the development of each painter's genius through his career.

David Piper

Introduction

Henri Marie Raymond de Toulouse-Lautrec Monfa was born on 24 November 1864 at the family home, the Hôtel du Bosc. It was close to the old city walls of Albi and only a short distance away from the great fortified cathedral of Sainte-Cécile and the Palais de la Berbie, the archbishop's palace which, less than sixty years later, was to become the Musée Toulouse-Lautrec.

The year before his father, the Count Alphonse, had married his first cousin Adèle Tapié de Céleyran. Both were descended from old Albigensian families. Young Henri's early years passed pleasantly and uneventfully: both his grandmothers adored him and he was spoilt by his parents and his numerous aunts and uncles.

Count Alphonse was a cavalry officer but he soon abandoned his military career to devote himself entirely to hunting and shooting, leaving the management of the family estates to a steward. Lautrec's father was a noted eccentric, but he had style. In sport – which meant training horses and dogs and, above all, falcons which were to become his greatest passion – he found the scope he needed for his superabundant energy.

The artist's mother was a much more reserved character who suffered greatly from her husband's eccentric behaviour and devoted herself entirely to her son's education. As a child he was brimming over with health and charm – a good-looking, sturdy boy who shared the family passion for hunting, horses and dogs. The death of a younger brother in infancy strengthened the bond between mother and son. The young Henri spent his childhood on the family estates, at Céleyran amid the vineyards or at the Château du Bosc north of Albi. A large staff was kept – in those days farming required many hands – and there was a constant coming and going of aunts and uncles, friends and young cousins of his own age. His education must have suffered in consequence and his parents decided to move to Paris, where Count Alphonse had kept an apartment, so that Henri could attend the lycée. Here he met Maurice Joyant who was to become his lifelong friend, and they vied with each other for

success in the schoolroom. Lautrec was a brilliant student, with a gift for witty repartee which characterized his relations with others until the end. Joyant, whom he met again some years later, proved a staunch friend and it was he who founded the Musée Toulouse-Lautrec at Albi.

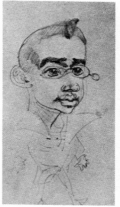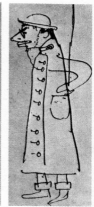

Two self-portrait caricatures by Lautrec. (left): *pencil, 26.5 × 16.3, private collection, c. 1882.* (right): *pen, 17.5 × 11.2, Albi, Musée Toulouse-Lautrec, 1885*

From early childhood Lautrec drew, sketching everything he saw: horses, dogs, game, hunting and farming scenes. It came to him quite naturally, for everyone in his immediate circle either drew or painted in watercolours. On their return from hunting they tried to reproduce the scenes they had witnessed, the hare they had put up or the woodcock that had been shot in flight. Sketchbooks by all the members of the family have survived, in particular those of the artist's uncle Charles de Toulouse-Lautrec. For Henri, with his quick and lively mind, the hours spent in the classroom dragged and he scribbled all over his books and his exercise books. Sometimes he sketched from memory the animals he knew so well; sometimes he invented scenes from mythology; and some-

3

The house at Céleyran, one of the family homes where Lautrec spent his childhood. He often stayed there as an adult and painted the scenery and people of the locality.

times, when he felt like it, he made caricatures. Most of them are either portraits or they represent people and animals caught in action: birds on the wing, horses rearing up, horsemen riding at full gallop or oxen yoked to a cart, fishing scenes or amusing incidents like a dog taking a bite out of a fat gentleman's bottom. And, of course, he drew his teachers! Many of these prolific early examples of the artist's talents are preserved in the Musée Toulouse-Lautrec, and when a drawing the size of a postage stamp is examined through a magnifying glass both the precision and quality of line and the artist's profound originality in the depiction of movement become apparent.

When Henri was in his fourteenth year disaster struck and changed the whole course of his life. Lautrec described the incident in a letter to a friend: 'My dear Charles. You will surely forgive me for not having written to you sooner when you learn the reason for the delay. I fell off a low chair on to the floor and broke my left thigh. But now thank God the bone has knitted together again and I am beginning to walk with a crutch and someone to help me . . .' The final blow fell a year later in August 1879 during the course of a visit to the health resort and spa of Barèges. Lautrec fell into a ditch and broke the other leg. It transpired that he was suffering from a serious bone disease and his legs ceased to grow, causing an ungainly gait. His arms and body, however, developed normally and at exactly five feet in height he was hardly any shorter than many of his contemporaries.

It was good-bye to normal life, to riding, hunting and school. Lautrec was doomed to go from spa to spa, from watering-place to watering-place in the attempt to regain the use of his legs. His mother went with him and saw to it that he kept up his studies with the aid of private tutors, but the days seemed long to a high-spirited adolescent who needed an outlet for his energies. This he found in reading, in practising English, which he spoke perfectly, and above all in drawing and watercolours. Encouraged by his uncle Charles he also began painting in oils, and Lautrec's first canvases depict the subjects he knew best: horses, which he had drawn so often, are shown by themselves or with riders, trotting or galloping. The winter following his second accident was spent at Nice. The spectacle of the port with its boats and its sailors and the animated scene afforded by the Promenade des Anglais, its glittering carriages and fashionable women, made Lautrec feel the need to capture this teeming life from which he was henceforth excluded. *The Promenade des Anglais at Nice* (No. 31) shows a fashionable lady at the reins of her victoria being greeted by a passing horseman, while her groom sits behind her with arms folded. The execution of the elegant carriage and the well turned-out horses foreshadowed the standard of work Lautrec was to produce in the next four years when he was to demonstrate that

the qualities requisite for the fulfilment of his passion for painting were already fully present. He filled sketchbooks with drawings and watercolours: the seaman hoisting the flag, the fisherman with his net, the sailor standing with both legs firmly apart smoking his pipe, the rowing boat coming in alongside, the sailing boat disappearing over the horizon, the oarsmen seen from the quay, only their caps and their round caps visible, and the deliveryman's horse at rest, munching the oats in its nosebag.

Lautrec also wrote a great deal. It was characteristic of his frank, open nature that his wit, though caustic, was never malicious. He never indulged in self-pity and, on the contrary, made fun of himself. In order to fill the empty hours he made up stories with pictures about the little incidents in his life and the people he had seen or met and sent these unusual journals to friends or members of the family. One such was: '*Cahier de zig-zags*, dedicated to my cousin Madeleine Tapié, with the laudable aim of distracting her a little from the lessons of Madame Vergnettes.'

At Barèges Henri had met a friend of his own age, Etienne Devismes, whose health was also delicate, and who later presented the letters he had received from Lautrec to the Musée Toulouse-Lautrec at Albi.

'Nice, 1879
. . . On Monday' [wrote Henri] 'the surgical crime was committed and the fracture so admirable from the surgical point of view (though not of course from mine) was revealed. The doctor was delighted with it and left me alone until this morning when, under the pretext of getting me to stand up, he let my leg bend at a right angle causing me agonies. Ah! if only you were here just for five minutes of each day I could contemplate my future suffering with equanimity! I spend my time making the hatches for my boat (the bowsprit and bobstays only took half a day) . . .'

'Nice, 11 February 1880
. . . We are boiling here in the sun. I say boiling because two days ago, just in time for the Carnival, the heavenly Father opened the celestial floodgates to their fullest extent . . . As far as boats are concerned my mania has somewhat diminished or rather it has changed its nature; I now have painting mania. My room is full of objects which hardly even deserve the designation of crude daubs. But it passes the time . . .'

In order to give Henri something to do Devismes sent him his charming short story *Cocotte* to illustrate. It related the delightful adventures of an old horse, Cocotte, and her owner, a priest. Lautrec produced twenty-three drawings to adorn this tale but it was not published until very much later, in 1953.

During this same period Lautrec also spent some time down on the family estates where he painted the people and sights around him: his young cousin Raoul Tapié de Céleyran sits on a donkey and brandishes his riding crop above the head of his refractory mount (No. 72); the kennel-lad waits for the hunt to move off while behind him a rider leaps into the saddle (No. 70); a pair of yoked oxen gaze at us impassively (No. 81). Lautrec also painted himself. There is a self-portrait in front of a mirror (No. 61) with the face in shadow as though he were afraid to reveal features unlovely even in youth, but in his later years he was to have no hesitation in exaggerating his own ugliness not only in his paintings but also in drawing many self-caricatures. It was long hours spent at his mother's side and the affection he felt for her that found expression in his first masterpiece in 1881. The Countess of Toulouse-Lautrec is represented sitting very upright in her high-backed chair at a table (No. 75). The muted tones of the background and of her dress encircle and illuminate the two focal points of the canvas: the serene, gently smiling face and the hands which rest calmly and naturally on the table.

In the same year Lautrec took up his studies again. He worked hard and managed to pass the first half of his Baccalauréat, but encouraged by his artistic success and with the backing and support of his uncle Charles and of René Princeteau, a deaf-mute painter of horses and hunting scenes, he secured permission to abandon his studies and devote himself full-time to painting.

Winter found Lautrec back in Paris, his mentors an eccentric father and a superficial

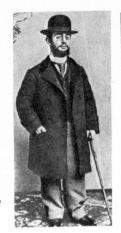

There are many photographs of Toulouse-Lautrec, providing a vivid record of his personality and eccentricities

and worldly painter. As Princeteau's pupil Lautrec met other members of the artist's circle, and for one of them, John Lewis Brown, he conceived a lively admiration. They all rode in the Bois de Boulogne and frequented the races and the horse shows. They loved to watch highly-trained animals perform difficult feats and the circus was their favourite distraction in the evenings. The paintings by Lautrec which date from this period are strongly marked by this somewhat confused mixture of influences, as in his *Souvenir of Auteuil* (No. 80), also known as *At the Races at Auteuil*. The horse has lost the strength and balance which Lautrec had invented for himself during the preceding months and is closely modelled on those of Princeteau. The figures and the background of trees and grass recall Brown. But an ironical note is struck by a small grotesque silhouette which is Henri's unflattering way of depicting himself. Already the pupil had outstripped his master and those he admired, but none of them seemed to realize it.

Once again it was his uncle Charles who steered Henri towards fresh horizons. But let us leave it to the artist himself to inform us about the new direction he was taking in a letter which he wrote to his uncle:

'Paris, 22 March 1882
My dear Uncle,
As promised, I am keeping you in touch. On Sunday or Monday I am going, with everyone's approval, to Bonnat's studio. Princeteau will introduce me. I've been to see the young painter Rachou who is the friend of Ferréol and a student of Bonnat's. He is beginning to work on his own and has submitted a painting to the exhibition . . .

. . . More about my plans. I shall probably enrol at the Ecole des Beaux-Arts and take part in their competitions while continuing to study under Bonnat. It's all very exciting especially with the prospect of the

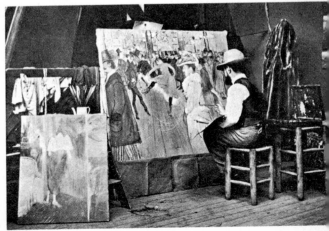

Lautrec at work on The Dance at the Moulin Rouge *(No. 305), one of his finest works, which was bought by Joseph Oller, proprietor of the music hall, to hang above the bar*

Horse Show and visits to La Marche and Auteuil. On Monday we had dinner at Uncle Odon's. The hairdresser's clippers have been at work on that family. Raymond now has his hair close-cropped at the temples and Mlle Mahéas has acquired an unruly and untidy fringe . . .'

But summer came all too soon and Bonnat decided to close his studio. Lautrec rejoined his mother first at the Château du Bosc where he wrote, 'I'm dividing my leisure between painting and toothache, an inexhaustible source of the most diverse sensations', and afterwards at Céleyran.

The works of Lautrec's leisure that summer enable us to assess the young artist's achievement after only six months in Paris which included the three short months in Bonnat's studio. Surprisingly it was Bonnat who, twenty years later, vetoed the acceptance by the Louvre of a masterpiece by the young Lautrec, whose brilliant talents had created such original and important works during the course of his short life. There exists a caricature drawn by Lautrec which shows the first meeting between the two men.

A big-bellied Bonnat eyes the diminutive form of young Henri who bows low before him; one says 'Bonnat' and the other replies 'Monfa'. That was the year when Lautrec signed with his third name, whereas both previously, and subsequently, he signed H T L or H T Lautrec and even, on occasion, Tréclau, an anagram of Lautrec.

During the summer of 1882 Lautrec produced an impressive number of large drawings (about 65 × 54 cm) of anyone he could persuade to sit for him. There are drawings of his uncle Charles, both in profile and full-face, sitting reading a book, his legs crossed, or reading Le Figaro with his legs stretched out and resting on a chair in front of him. There are others of both his grandmothers, drawn head and shoulders, his mother sitting in a chair in the garden doing embroidery, and his father sitting drawing at a table. Paintings, too, exist relating to these drawings: Count Charles de Toulouse-Lautrec in an armchair reading the paper (No. 158); the Countess, full-face, sitting on a bench in the shade (No. 147) and in profile before a great mass of flowers (No. 156).

There is also a still life, interesting for being virtually unique in Lautrec's work, a flower in a pot on a small table (No. 157). All these works testify to the skill Lautrec had already acquired in the practice of his art and confirm his desire to represent daily life. Very different from the usual domestic themes is the *Nude Woman* (No. 139). Though somewhat clumsy, the academic pose oddly allied to the warmth and freedom of the colour, this study foreshadows Lautrec's later fervent pursuit of truth in painting the human face, the human body and the human body in movement against simple backgrounds which throw the figure into relief. Always life itself would be his chosen subject.

'Le Bosc, Thursday
Dear Papa
Bonnat has dismissed all his students. Before coming to a decision I canvassed the views of my friends. They are unanimous, and I have accepted an easel in Cormon's studio. Cormon is the young and already famous painter of *Cain fleeing with his Family*, now in the Luxembourg. An austere, powerful and original talent. Rachou phoned me to ask if I was prepared to join some of my comrades there and I accepted. Princeteau approves my choice. I had thought of trying Carolus but this prince of colourists produces mediocre draughtsmen and this would be fatal for me.

After all, it's not like getting married is it? The choice of possible teachers is by no means exhausted.

I hope I shall succeed in winning your approval for my choice which is no idle whim but based on serious considerations . . .'

Lautrec spent the next two years hard at work. Every morning he went to Cormon's studio on the heights of Montmartre. In the afternoon he worked at home or with his comrades, or else haunted the Salon and the exhibitions. He wanted to see and know everything and studied the paintings of his elders eagerly. He was still living with his mother in the Faubourg Saint-Honoré and took little or no part in the life of Montmartre, which was not yet the pleasure district it later

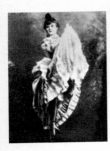

Three of the many women who figured in Lautrec's life and appeared in his work: (left to right):
*Louise Weber, 'La Goulue', a famous quadrille dancer at the Moulin Rouge 1890–5; Hélène Vary,
a neighbour of Lautrec's in Paris (this photograph inspired painting No. 266); Carmen Gaudin, an
artist's model in Paris, the 'redhead' who appears in a number of Lautrec's works (compare this
photograph with painting No. 251)*

became, but still rural in character, with colonies of artists settled among the vineyards and the mills.

Lautrec, with his keen wit and bantering good humour, found ready acceptance in a happy, carefree band of young artists whose number included André Rachou, Adolphe Albert, Emile Bernard, René Grenier and Louis Augustin. They all came from well-off families and their only preoccupation was to find another path for themselves outside official painting and the Ecole des Beaux-Arts. Young Henri's youthful ambitions had undergone considerable modification but he worked so hard and with such enthusiasm that both his family and his friend Princeteau gave him their blessing.

Many rather academic drawings and a number of similar canvases have survived from this period but watercolours are conspicuous by their absence and they remain so for a period of approximately ten years, after which Lautrec began to make posters and was attracted to lithography. In addition to these studio works the artist still took pleasure in depicting his family and friends, and hunting scenes and riders in the Bois de Boulogne, the latter being among his last works on that theme. *Crossroads in the Forest* (No. 175) emphasizes horses and people at the expense of the landscape whose only function is to throw the subjects into greater relief. This painting and Lautrec's fine drawing *The Skaters*, which shows a man and a woman holding hands, clearly indicate the direction all his future work would take: to depict life and to capture it in movement.

In order to discover where Lautrec stood in relation to contemporary painting, both official and otherwise, it is enough to read the many accounts which he wrote of visits to exhibitions. This one is a good example of both his style of writing and his intelligence. The Boudin exhibition.

'I have been to see the Boudins.

He's an artist who well deserves an exhibition to himself. I've no intention of delving into his past. What does it matter whether he is the son of an ordinary seaman, an able seaman, a quartermaster or a bos'un? He's an original painter and in spite of his greyish monotone style always a delight. His beach scenes are very amusing and I must mention his *Port of Le Havre in a Storm*, the white sails standing out against a violet sky; it doesn't fit in at all with those hundreds of other studies which fill five or six halls. The man is dedicated . . .'

By this time Lautrec was twenty and thirsting to lead his own life. That summer he took the opportunity to kick over the traces, and moved to Montmartre, staying with various artist friends in turn: first with Grenier, whose charming wife Lily often modelled for him, then with Rachou and finally with Dr Bourges whom he used to visit even after he had his own studio. In the end his family gave in and allowed this unmanageable youngster, who was already beginning to burn the candle at both ends and lead a dissolute life, to set up on his own. He took a studio in rue de Tourlaque at the foot of Montmartre where his friends lived, and not far from Degas' studio, a circumstance which was to exert a powerful influence on Lautrec's artistic development.

Lautrec and his friends met regularly most mornings at Cormon's studio and worked at home or in the garden of a neighbour called Forest in the afternoon. When the light began to fail they went out and met in the cafés, and visited the theatre, the opera or the circus. With his physique Lautrec could not pass unnoticed; his deformed body made it unnecessary for him to adopt peculiar or eccentric modes of dress as many of his comrades did. Instead he exaggerated his deformity and his limping walk, leaning on a short stick, which he was never without.

Degas, Detaille and the Italian artists with Boldini at their head gathered in the little restaurants at the foot of Montmartre while Lautrec and his friends, hankering after bright lights and noise, used to haunt the dance-halls of the Moulin de la Galette and the Elysée-Montmartre where La Goulue, Nana la Sauterelle, Grille d'Egout and Rayon d'Or flaunted themselves with Valentin le Désossé. Lautrec also frequented the nightclubs on the boulevards, the Divan Japonais and the Cirque Fernando. He and his riotous group of friends would finish the night in a brasserie arguing endlessly, drinking, singing and laughing. Very often the evening finished at Salis' *Chat Noir* where Aristide Bruant made his début. Soon Bruant set up on his own under the sign 'Mirliton, customers who like being insulted' and it became fashionable to brave the chorus of shouts which greeted each new arrival.

In 1885 Bruant asked Lautrec to illustrate his song *A Saint-Lazare* (this was the name of the prison where prostitutes arrested by the police were taken). This was Lautrec's first lithograph, but he did not become really interested in the art or take it up seriously until six years later. In the following year he painted a picture with the same subject (No. 223) which he dedicated 'To the author of *Saint-Lazare*'. It was unusual for Lautrec to follow the original lithograph with a later painting, for in future he would make his finest drawings and paint his most beautiful cartoons in preparation for a 'simple' lithograph.

Among the models who posed for Lautrec during this period of his life was the red-haired Carmen Gaudin (Carmen la Rousse). Her face fascinated him and he painted her many times, full face, in profile or with bowed head. Another model was Suzanne Valadon who had also modelled for Puvis de Chavannes, Degas and Renoir. At that time she called herself Marie – she did not change her name until she too became a painter – and was already the mother of the young Maurice Utrillo. As he had always done, Lautrec also painted his immediate circle: his mother, Lily Grenier and her husband, François Gauzi and the Pascal family.

The works of his neighbour Degas, whom he greatly admired, had deeply impressed Lautrec. He too painted scenes from the ballet, sketched dancers resting or waiting in the wings and drew the men and women strolling in the foyer, entering or leaving the boxes, and arriving at or departing from the theatre. He extended his palette in order to capture that sense of movement that was all-important to him. He was already at the height of his powers as a painter of portraits.

At Cormon's studio, which he still attended from time to time, Lautrec was introduced to Van Gogh by Emile Bernard. Following in Seurat's footsteps, Van Gogh was already launched on the quest which was to take Impressionism far beyond the limits set to it by Monet and Renoir. Too unalike to become friends, Van Gogh and Lautrec, who was eleven years younger, followed the same path using very different means and methods. Fate was equally unkind to these two loners, for both died at the age of thirty-seven – consumed by the hunger for life which they tried to express in their works. Both outgrew

the influence of the Impressionists and both were rebuffed on account of the kind of world they depicted.

Van Gogh felt stifled in Paris and soon left, but a record survives of their meeting in a pastel by Lautrec (No. 226) which shows that other *enfant terrible* of painting seated at a café table with a glass in front of him. Van Gogh's hidden strength can be seen in the expression of concentration on his face and in the energy of the hands.

It was through Van Gogh that Lautrec came to visit Goupil's, the picture-dealers, whose smaller gallery in Paris was directed by Théo Van Gogh. Later Théo's place was taken by Lautrec's school friend Maurice Joyant and their old friendship was renewed, never to be broken. After Lautrec's death Joyant, faithful to the memory of their friendship, used the thirty years of life remaining to him to serve the cause of his friend's art.

Lautrec used street scenes and scenes in night clubs for magazine illustrations for *Le Rire* and *Paris Illustré*. These represented the first money he earned from his art. He had given paintings to his friends but no-one had thought of buying one. The only exhibition of his works was the permanent one on the walls of the Mirliton, displayed there by Aristide Bruant: '*A Saint-Lazare*' (No. 223), *The Refrain of the Louis XIII Chair* (No. 213), *The Quadrille of the Louis XIII Chair* (No. 214), '*A Montrouge*' (No. 251), '*A Grenelle*' (No. 254), and '*A Batignolles*' (No. 252).

Lautrec was now at his peak, producing an ever increasing number of powerful works. The period 1888–90 shows him to be fully equipped both technically and artistically to attempt the new and untried field of poster design and lithography. By so extending himself he strengthened his claim to greatness. It is difficult to decide who compels the most admiration: the powerful and incisive draughtsman or the light and delicate water-colourist; the painter, direct and uncompromising, or the master of the poster, the precise and classic lithographer. Our fullest admiration should perhaps be reserved for Lautrec's versatility, which allowed him to undertake every branch of his art.

The works of 1888–90 include: *At the Cirque Fernando: Equestrienne* (No. 258), the gaily dressed rider turning, perched lightly on her enormous mount; *Redhead in a White Jacket* (No. 263) posed in the studio; *Studio Model: Hélène Vary* (No. 266); *Portrait of the Actor Henri Samary* (No. 275), the actor standing with both legs firmly apart and adjusting his spectacles as he surveys the scene at the Comédie Française; *Portrait of Henri Fourçade* (No. 276) a *habitué* of the dance halls; and *At the Moulin de la Galette* (No. 280).

Woman after woman was painted in Forest's garden; model succeeded model in the studio. Lautrec worked furiously. He went out in the evenings, often to the theatre, and spent the night drinking and drawing. During the day he painted or went on trips into the countryside. And yet he still found time to paint masterpieces: *The Washerwoman* (No. 290) leaning wearily on the table, her loose white jacket linking hand and profile; *Seated Dancer* (No. 314), so far removed from those he had painted only two years earlier; and *Dance at the Moulin Rouge* (No. 305) with the lanky silhouette of Valentin-le-Désossé as he and his partner throw themselves into the dance. The way now lay open to that flowering of Lautrec's art which gives such joy to artlovers today.

Artilleryman saddling his Horse (No. 13)
Military manoeuvres near the Château du Bosc, the Lautrec family home, were the subject of other similar paintings by Lautrec.

Catalogue of the Paintings

After Lautrec's death Joyant stamped a number of unsigned paintings with a red seal of the painter's monogram in a circle. In the catalogue the term 'red seal' refers to these paintings.
All measurements are in centimetres.
s.d. = signed and dated.

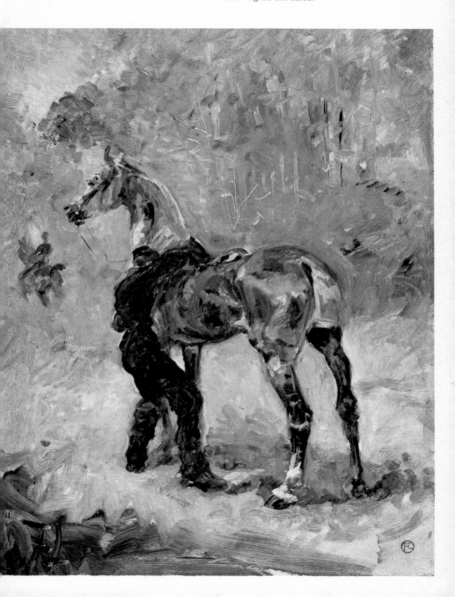

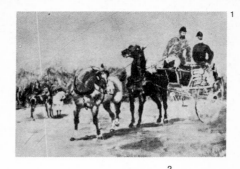

1 **Carriage and Pair**
Cardboard/25 × 32/s. 1878
Private collection

2 **Niniche**
Canvas/22.4 × 28/1878
Private collection

3 **Monsieur**
Wood/33 × 23/s. 1878
Private collection

4 **The Hussars**
Canvas/27 × 32.5/s.d. 1878
Paris, private collection

5 **Bruno**
Wood/18 × 26/s.d. 1878
Private collection

6 **Riders**
Canvas/30 × 47/c. 1878
Private collection

7 **Huntsman on Horseback**
Wood/35 × 25/1879
Private collection

8 **Huntsman on Horseback**
Cardboard/35 × 25/1879
Private collection

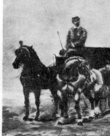

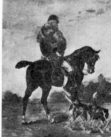

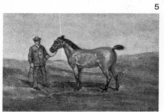
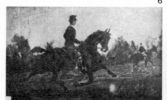

*Carriage and Pair from behind
(No. 15).
In later drawings of the same
subject Lautrec was to
recapture the vivid immediacy
of this composition.*

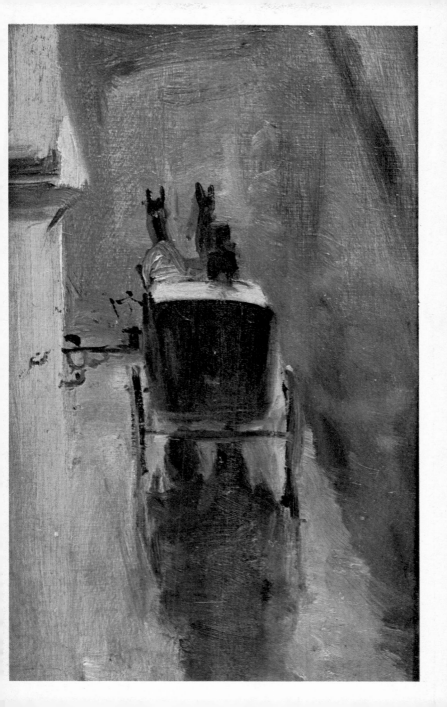

9 Huntsman saddling his Horse
Wood/24 × 16.5/s. 1879
New York, private collection

10 At the Races at Chantilly
Canvas/47 × 58/s.d. 1879
Belgium, private collection

11 At Le Bosc
Canvas/47 × 60/s. 1879
Belgium, private collection

12 Cuirassiers on Horseback
Canvas/40 × 33/s. 1879
Private collection

13 Artilleryman saddling his Horse
Canvas/50.5 × 37.5/s. 1879
Albi, Musée Toulouse-Lautrec

14 Artillery on Field Service
Canvas/60 × 73/red seal/1879
Private collection

15 Carriage and Pair from behind
Wood/23.5 × 14/1879
Albi, Musée Toulouse-Lautrec

9

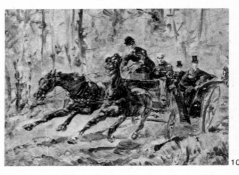

10

12

1

13

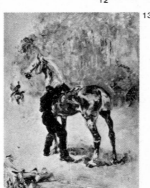

15

14

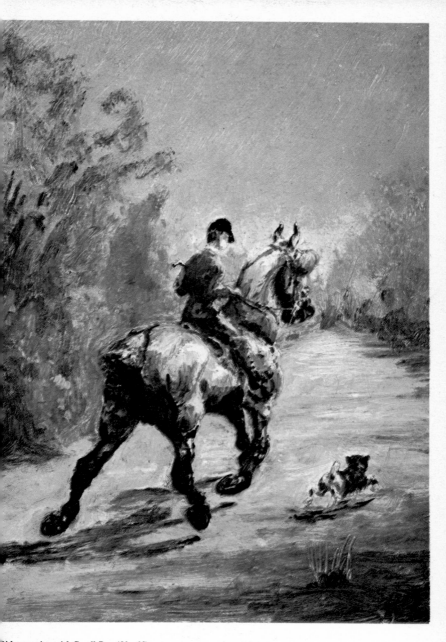

Rider trotting with Small Dog (No. 18).
Princeteau's influence is apparent here, but the sense of movement, horse and dog
leading with the same foot, is Lautrec's own.

16 Portrait of a Man
Wood/23.8 × 16.4/1879
Albi, Musée Toulouse-
Lautrec
On the back: *Seated Nude*
(drawing)

**17 Artillerymen on Horseback
at Le Bosc**
Canvas/64 × 49/1879
Albi, Musée Toulouse-
Lautrec

**18 Rider trotting with Small
Dog**
Cardboard/32.5 × 23.8/s. 1879
Albi, Musée Toulouse-
Lautrec

19 Huntsman on Horseback
Wood/14 × 23.4/1879
Albi, Musée Toulouse-
Lautrec
On the back: *Front-view of a
Horse* (1881)

20 Portrait of a Spaniard
Wood/23.5 × 14/s. 1879
Albi, Musée Toulouse-
Lautrec

21 Bust-portrait of a Man
Wood/23.5 × 14.1/s. 1879
Albi, Musée Toulouse-
Lautrec

22 Bust-portrait of a Sailor
Wood/23.5 × 14.1/s. 1879
Albi, Musée Toulouse-
Lautrec

23 Trap
Canvas/24.5 × 19/s.d. 1879
Switzerland, private
collection

24 Carriage
Canvas/31 × 26/1879
Private collection

Kennel-lad (No. 36).
The straining dogs and the
figure of the lad stand out
against the landscape which,
as always in Lautrec's work, is
relatively under-stated.

16

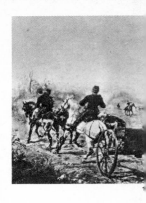

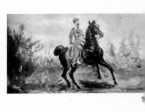

18

20 21

23

24

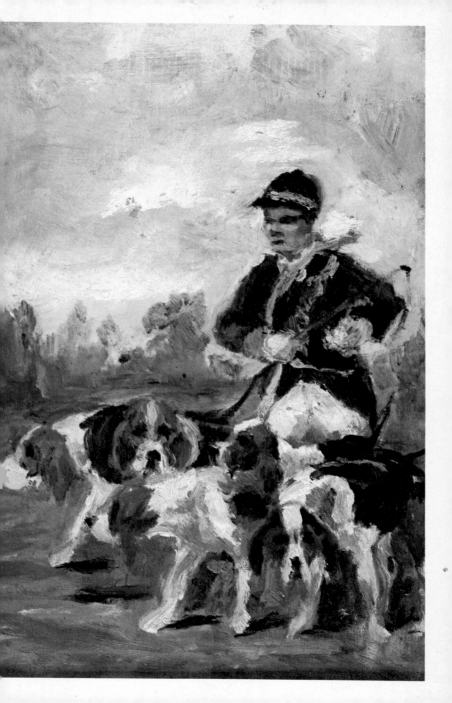

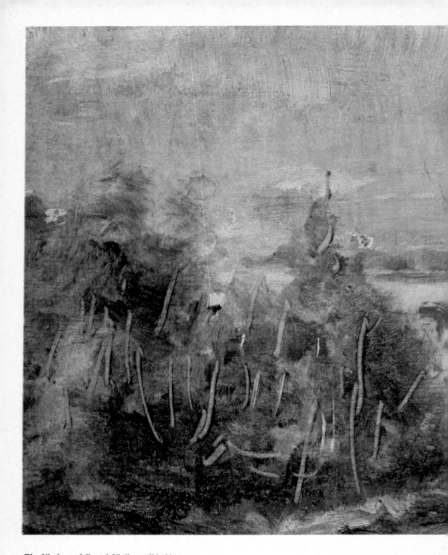

The Viaduct of Castel-Vieil at Albi (No. 30).
Painted from the terrace of the Hôtel du Bosc, the artist's birthplace, and the only surviving view of Albi by him.

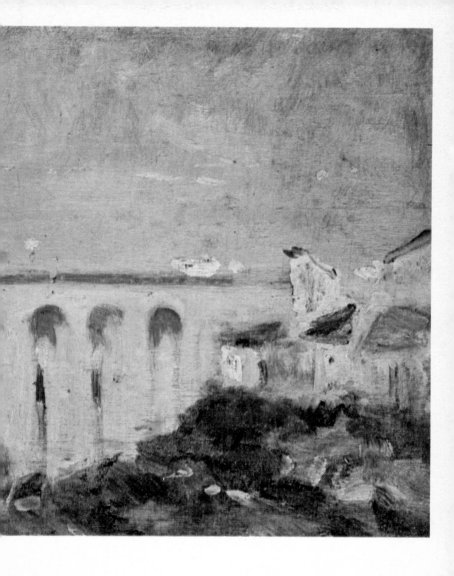

25 Artilleryman on Horseback
Wood/17 × 24/1879
Toulouse, private collection

26 Bust-portrait of a Man
Canvas/14.5 × 9.9/1879–80
London, private collection
Painted on an album cover

27 Touc
Wood/12.5 × 22/1879–81
Private collection

28 Touc sitting on a Table
Wood/23.5 × 14/1879–81
Amsterdam, Van Wisselingh
Collection

29 Huntsman on a Hunter,
walking
Wood/16 × 22/s. 1880
Belgium, private collection

30 The Viaduct of Castel-Vieil
at Albi
Wood/14.1 × 23.4/1880
Albi, Musée Toulouse-
Lautrec

31 The Promenade des Anglais
at Nice
Canvas/31.5 × 40/s.d. 1880
Private collection

32 Dog-cart
Canvas/18 × 24/s. 1880
Upperville (USA), Mellon
Collection

33 Hunter
Wood/24 × 18/s. 1880
Paris, private collection

34 Whipper-in
Wood/18 × 24/s. 1880
Formerly in Paris, Ellissen
Collection
Stolen at the Brussels
Exhibition of 1947

35 Sailor sitting on the Prow
of a Ship
Wood/21.6 × 12.6/s. 1880
Albi, Musée Toulouse-
Lautrec
On the back: *Sketch of a*
Rider. There are two more
paintings of marine subjects
with men-of-war in a private
collection in France

Head of a Dog (No. 41).
Lautrec loved dogs and
painted them throughout his
life. He kept one in his studio
with him for several years.

25

26

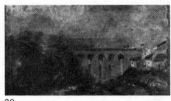
29

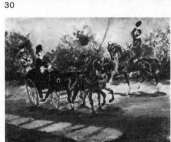
30

28

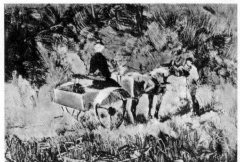
31

32

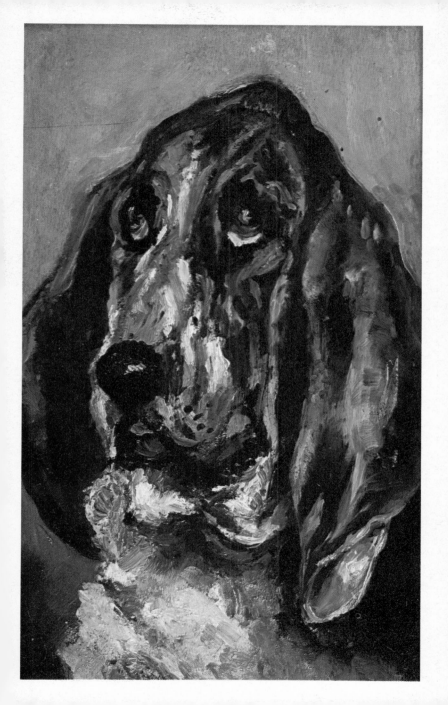

36 Kennel-lad
Wood/23.5 × 14.1/1880
Albi, Musée Toulouse-
Lautrec

37 Rider in Eighteenth-century Dress
Wood/14.1 × 23.5/1880
Albi, Musée Toulouse-
Lautrec

38 Horsewoman with Groom
Wood/14.1 × 23.4/s.d. 1880
Albi, Musée Toulouse-
Lautrec
On the back: *Dog-cart*

39 Two Horses with a Groom
Wood/12.8 × 21.6/s. 1880
Albi, Musée Toulouse-
Lautrec

40 Céleyran, Balcony overlooking the Park
Wood/23.8 × 16.6/1880
Albi, Musée Toulouse-
Lautrec

41 Head of a Dog
Wood/23.4 × 14.1/1880
Albi, Musée Toulouse-
Lautrec

42 Head of a Dog with Short Ears
Wood/14.1 × 23.5/1880
Albi, Musée Toulouse-
Lautrec
There is another small study
of dogs in this museum

43 Peregrine Falcon
Wood/23.8 × 16.8/1880
Albi, Musée Toulouse-
Lautrec
On the back *A Stop in the Desert*

44 In the Fields
Wood/16.5 × 23.9/1880
Albi, Musée Toulouse-
Lautrec
On the back: *At the Theatre (The Box)* 1881

45 By the River at Céleyran
Wood/16.6 × 23.8/1880
Albi, Musée Toulouse-
Lautrec
There are two more small
views of Céleyran in this
museum

33

34

35

36

37

4(

38

4

39

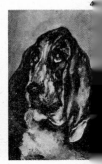

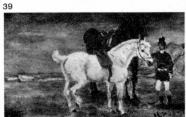

42

43

44

47

48

49

45

50

51

6

52

53

46 View of the Vineyards at Céleyran
Wood/16.5 × 23.9/1880
Albi, Musée Toulouse-
Lautrec
There is another painting of
the same subject and of
identical size in this museum

47 Pines at Céleyran
Wood/16.5 × 23.8/1880
Albi, Musée Toulouse-
Lautrec
On the back: *Head of a
Woman* 1885
There is another view of the
pinewood at Céleyran in this
museum

**48 Path through the Wood at
Céleyran**
Wood/22 × 16.5/1880
Albi, Musée Toulouse-
Lautrec

49 The Château de Céleyran
Wood/23.5 × 14.1/1880
Albi, Musée Toulouse-
Lautrec
There are two more views of
the countryside and wood at
Céleyran in private collections

50 Dog-cart
Wood/27 × 35/1880
Albi, Musée Toulouse-
Lautrec

**51 Terrace at the Château du
Bosc**
Wood/24.5 × 15.3/1880
Albi, Musée Toulouse-
Lautrec
On the back: *In the Stalls*
1882

**52 Kitchen Fireplace at
Céleyran**
Wood/24 × 18/1880
Albi, Musée Toulouse-
Lautrec
There are two paintings of
the cellar at Céleyran in this
museum

53 Old Man on a Bench
Wood/23.9 × 16.6/1880
Albi, Musée Toulouse-
Lautrec

Dog-cart (No. 50).
The horse shows Princeteau's influence more clearly than
previous works, though the dog-cart and landscape are typical
of Lautrec's own style.

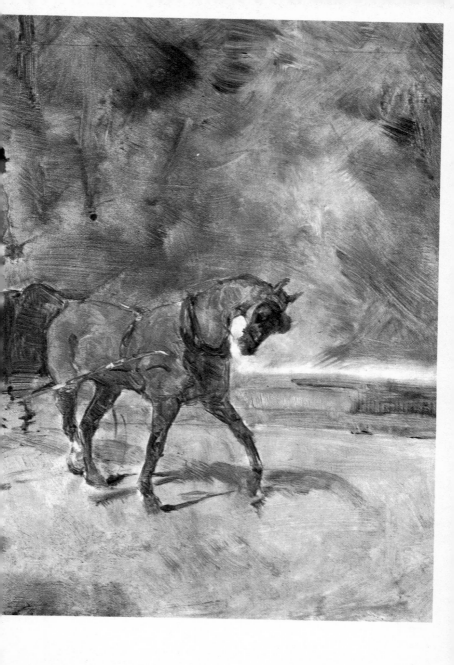

54 An 'Incroyable' (A Dandy)
Wood/23.8 × 16.6/1880
Albi, Musée Toulouse-
Lautrec

*55 Head of a Man with a
White Beard*
Canvas/16.7 × 10.2/1880
Albi, Musée Toulouse-
Lautrec

*56 Head of a Man with a
Peaked Cap*
Wood/23.9 × 16.6/1880
Albi, Musée Toulouse-
Lautrec

*57 Head of a Woman in
Profile*
Wood/17.3 × 23.8/1880
Albi, Musée Toulouse-
Lautrec
On the back: *On the Banks of
the River*

58 At Table
Wood/23.5 × 14/1880
Albi, Musée Toulouse-
Lautrec
On the back: *Under the Pines*
1881

59 Old Man at Céleyran
Canvas/41 × 33/1880
Albi, Musée Toulouse-
Lautrec

*60 Two Horses with an
Orderly*
Cardboard/32.5 × 23.8/1880
Albi, Musée Toulouse-
Lautrec

*61 Self-portrait of Lautrec in
front of a Mirror*
Cardboard/40.5 × 32.5/1880
Albi, Musée Toulouse-
Lautrec

54

55

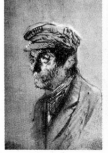

56

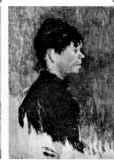

5

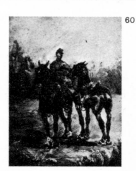

58

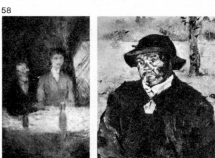

59

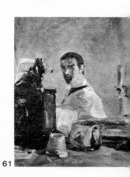

60

61

ld Man on a Bench (**No. 53**).
*he contrast between the dignified old gentleman sitting on
e bench and the young couple in the background gives a
retaste of Lautrec's sense of humour.*

62 Rider
Cardboard/50.7 × 34.9/1880
Albi, Musée Toulouse-Lautrec
There are two paintings from this period of similar hunting subjects in a private collection in Holland

63 Horse behind a Gate
Wood/23.4 × 14.1/1880
Albi, Musée Toulouse-Lautrec

64 Two Yoked Oxen
Wood/20 × 16/1880
Paris, private collection

65 Fishing Boat
Wood/14 × 23.2/1880
Toulouse, private collection

66 Head of a Dog
Canvas/22.5 × 14/1880
New York, Metropolitan Museum of Art (Furst bequest)

67 Head of an American Sailor
Canvas/22.5 × 14/1880
New York, Metropolitan Museum of Art (Furst bequest)

68 Rider Seen from behind
Wood/23.5 × 14.2/1880
Private collection

69 A Dog
Wood/13.5 × 23/d. 1880
Private collection

62 63

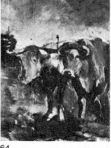
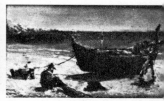

64 65

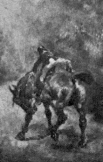

66

68

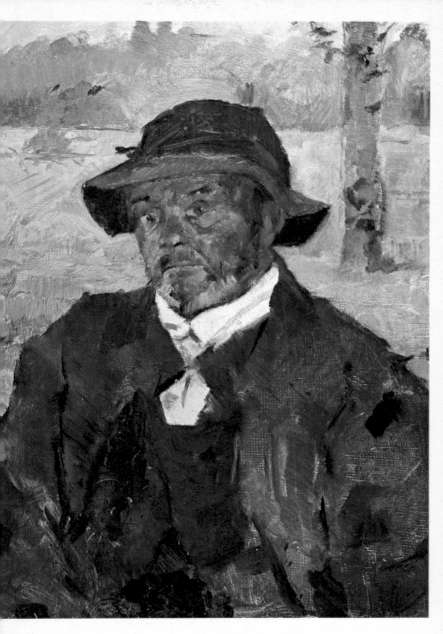

ld Man at Céleyran (No. 59).

typical labourer from the Céleyran vineyards. Lautrec
ten painted servants of the family.

70

72

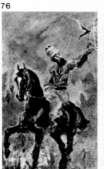

74

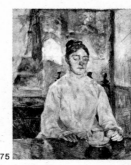

75

76

77

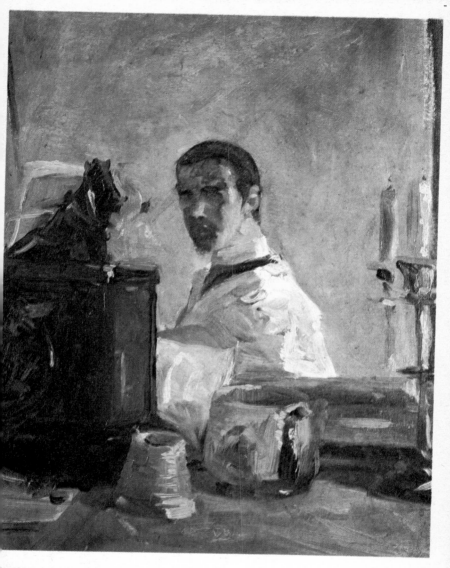

Self-portrait of Lautrec in front of a Mirror (No. 61).
Although Lautrec often drew himself in an unflattering light
and appears in several of his own paintings there are very few
actual self-portraits.

78 The Four-in-Hand (The Mail Coach)
Canvas/39 × 50/s.d. 1881
Paris, Musée du Petit Palais

79 Horse giving Trouble to his Lad
Wood/16.5 × 24/1881
Great Britain, private collection

80 At the Races at Auteuil
Canvas/68 × 53/s.d. 1881
Private collection

81 Two Yoked Oxen
Wood/33 × 41/1881
Bordeaux, Musée des Beaux-Arts

82 Cart Drawn by a Horse and a Mule
Canvas/40 × 60/s. 1881
Private collection

83 The Black Countess at Nice
Wood/31 × 38/s.d. 1881
Cambridge (USA), Fogg Art Museum, Harvard University

84 Cuirassier
Canvas/73 × 60/s.d. 1881
USA, private collection

78
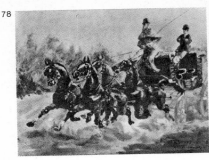

79

80

81

82

83
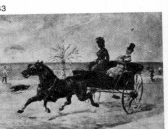

84

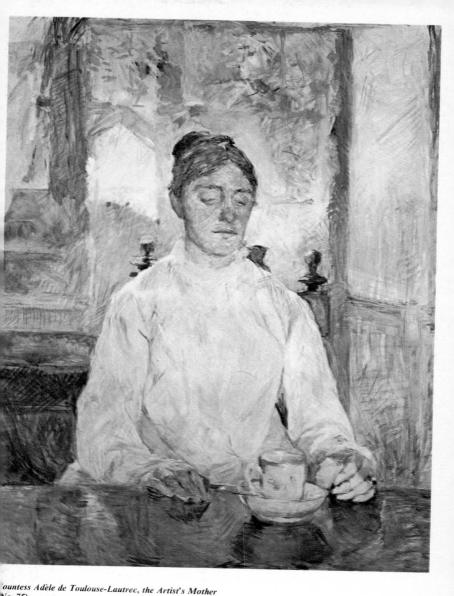

*ountess Adèle de Toulouse-Lautrec, the Artist's Mother
No. 75).
his portrait of his mother is Lautrec's first masterpiece. The
rtrait of* THE MODISTE, *painted twenty years later, was to
ve the same gentle luminous quality.*

85 Draught-horse at Céleyran
Canvas/63 × 71/red seal/1881
Albi, Musée Toulouse-
Lautrec
There is a small painting of a
similar subject in a private
collection at Libourne

**86 Head of a White Horse,
Gazelle, at Le Bosc**
Canvas/48 × 59/s.d. 1881
Albi, Musée Toulouse-
Lautrec

**87 White Horse, Gazelle, at Le
Bosc**
Canvas/60 × 50/s.d. 1881
Liechtenstein, private
collection

88 White Horse
Canvas/55 × 46/red seal/1881
Private collection
Two contemporary paintings
of horses are in private
collections

**89 Dun, Gordon Setter
belonging to the Artist's
Father**
Canvas/60 × 48/s.d. 1881
Private collection

90 Margot
Wood/35 × 26/s.d. 1881
Private collection

91 Gun-dog
Canvas/32 × 40/s.d. 1881
Private collection

92 Peregrine Falcon
Canvas/41 × 33/s.d. 1881
Switzerland, private
collection

93 Horsewoman
Wood/12.5 × 21.6/1881
Albi, Musée Toulouse-
Lautrec

**Count Alphonse de Toulouse-
Lautrec (The Falconer)
(No. 76).**
*It was always a great sorrow
to the count that his son could
not share his passion for
horses and hunting. An
eccentric figure, he is here
shown dressed in Circassian
costume out hunting with his
falcon.*

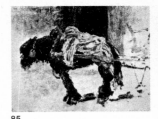

85

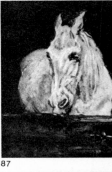

87

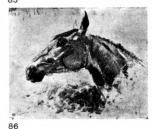

86

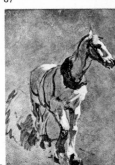

88

89

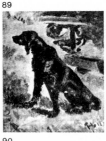

90

92

93

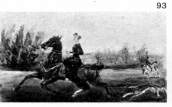

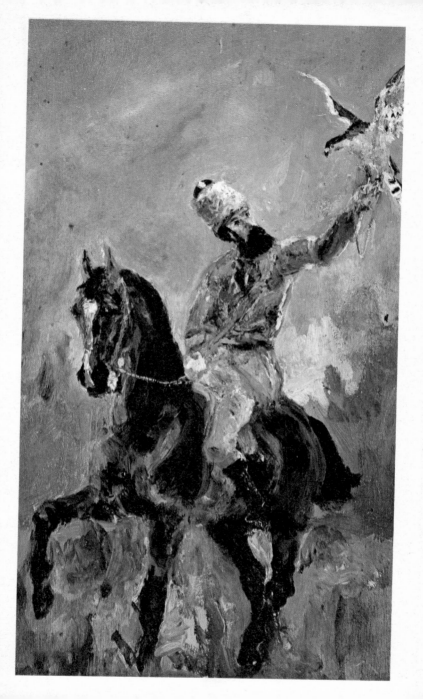

94 Carriage and Pair in front of a Gate
Wood/14.1 × 23.5/s. 1881
Albi, Musée Toulouse-Lautrec

95 Fishermen's Boat
Wood/14 × 23.4/1881
Albi, Musée Toulouse-Lautrec

96 Mabel, a Mare
Wood/21 × 12/s. 1881
Paris, private collection

97 At the Race-course
Wood/16.4 × 23.8/1881
Albi, Musée Toulouse-Lautrec

98 Little White Dog
Wood/23.4 × 13.8/d. 1881
Albi, Musée Toulouse-Lautrec

99 Cart on a Road
Wood/10.2 × 16.7/1881
Albi, Musée Toulouse-Lautrec

100 Young Monsieur Le Couteulx on an Ass
Canvas/46 × 38/1881
Albi, Musée Toulouse-Lautrec

101 Head of a Man (Etienne Devismes)
Canvas/61 × 50/1881
Albi, Musée Toulouse-Lautrec

102 The Artist's Mother reading
Cardboard/40.2 × 32.4/1881
Albi, Musée Toulouse-Lautrec

103 Raymond de Toulouse-Lautrec aged about Seven
Canvas/46 × 39/s.d. 1881
Private collection

104 Gabriel Tapié de Céleyran as a Child
Canvas/32.5 × 40.5/1881
Private collection

105 Two Yoked Oxen
Canvas/46 × 61/1881
Private collection
There is another similar, later sketch in a private collection

106 Horse Grazing
Wood/12.4 × 12.6/1881
Private collection

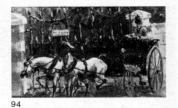

94

96

95

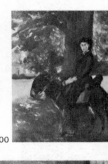

98

97

99

100

101

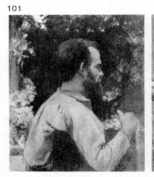

103

104

106

105

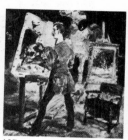

107

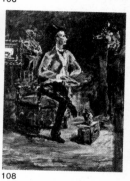

108

109

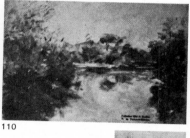

110

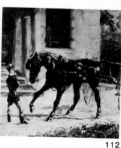

112

1

114

115

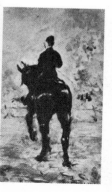

113

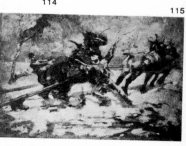

**107 The Painter René
Princeteau in his Studio**
Canvas/54 × 46/s.d. 1881
Private collection

**108 The Painter René
Princeteau in his Studio**
Canvas/73 × 54/1881
Private collection

109 Norfdac
Wood/23.5 × 14.5/s. 1881
Private collection
Two more studies of dogs
from the same period are in
São Paulo, Museu de Arte,
and in a private collection

110 River
Wood/16 × 24/1881
Private collection

111 Avenue
Wood/16 × 24/1881
Private collection

**112 Horse and Carriage with
Coachman**
Paper/26 × 24/s.d. 1881
Private collection

**113 Artilleryman on
Horseback seen from behind**
Wood/22.5 × 13/s. 1881
Private collection

**114 Head of a Souave wearing
a Fez**
Paper/21 × 13.7/1881
Private collection
Painted on an album cover

115 Cart in Difficulties
Wood/16.5 × 24/c. 1881
Private collection
On the back: **Study of Horses**
(drawing)

The Four-in-hand (No. 78).
*The coachman driving the
team of four horses at a gallop
is probably the artist's father.*

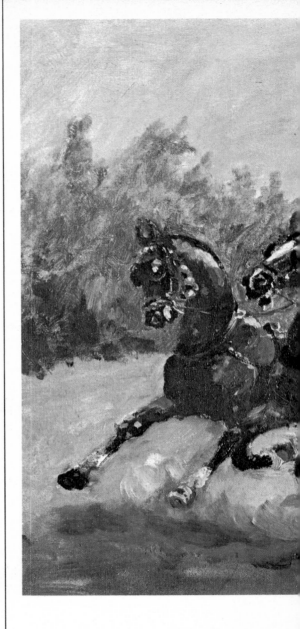

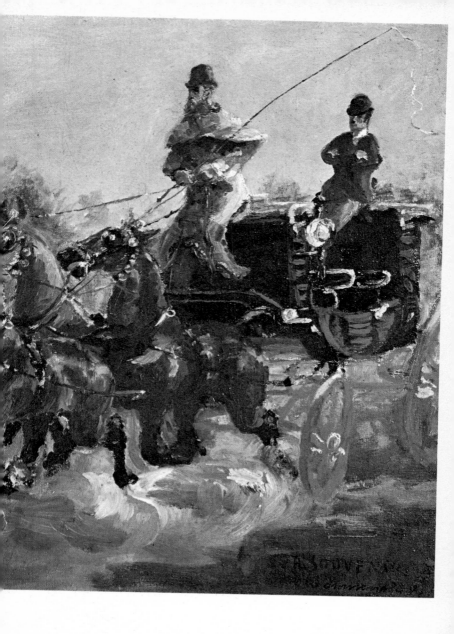

116 Flèche
Canvas/23.4 × 14/s. *c.* 1881
New York, Mellon Bruce
Collection

117 The Carriage
Wood/32 × 23.2/*c.* 1881
Philadelphia, William Coxe
Wright Collection

118 Hunting on Horseback
Canvas/41 × 32/*c.* 1881
Private collection

119 Tethered Horse
Canvas/49 × 59/s. *c.* 1881
Private collection

**120 At the Shop, Man
drinking (Père Mathias)**
Canvas/50 × 60/s.d. 1882
Private collection

121 A Labourer at Céleyran
Canvas/60 × 49/red seal/1882
Albi, Musée Toulouse-
Lautrec

**122 Old Woman sitting on a
Bench at Céleyran**
Canvas/53 × 44/red seal/1882
Albi, Musée Toulouse-
Lautrec

123 Young Routy at Céleyran
Canvas/61 × 50/red seal/1882
Albi, Musée Toulouse-
Lautrec

116

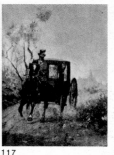
117

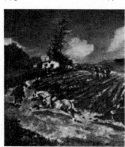
118

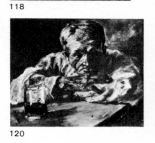

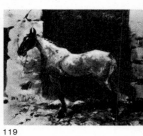
119

120

121

122

123

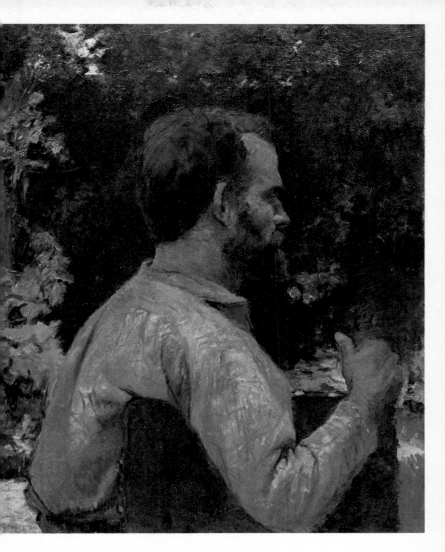

**ead of a Man (Etienne Devismes) (No.
1).**

*utrec's contemporary, and like him
or in health. They corresponded for a
ile and Devismes asked Lautrec to
strate a short story,* COCOTTE, *which
had written. The manuscript is now in
museum at Albi.*

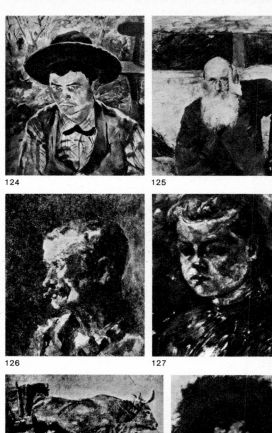

124

125

126

127

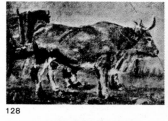

128

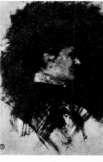

129

131

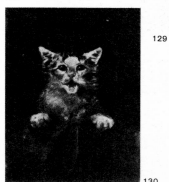

130

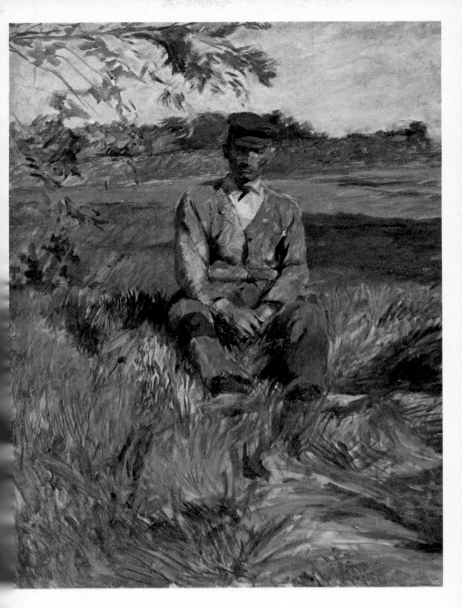

Labourer at Céleyran (No. 121).
...he red belt provides the only touch of
...olour in this painting.

132 Rider leading Two Horses
Wood/16.5 × 23.8/1882
Albi, Musée Toulouse-
Lautrec
On the back: *Horse's Head*

133 Horse in the Stable at Céleyran
Wood/23.9 × 16.5/1882
Albi/Musée Toulouse-
Lautrec
There is a similar painting
from the same period in this
museum

134 Torso
Wood/24.7 × 15/1882
Albi, Musée Toulouse-
Lautrec

135 Horse behind a Gate
Wood/16.5 × 23.9/1882
Albi, Musée Toulouse-
Lautrec
On the back: *Head of a Man
in Profile*

136 Profile of a Man's Head
Wood/23.8 × 16.6/1882
Albi, Musée Toulouse-
Lautrec
On the back: *Head of A
Woman*

137 In the Harem
Wood/22 × 15.9/1882
Albi, Musée Toulouse-
Lautrec

138 The Singing Lesson
Wood/16.5 × 23.8/1882
Albi, Musée Toulouse-
Lautrec
On the back: *Nude lying on a
Divan*

139 Nude Woman seated on a Divan
Canvas/55 × 46/1882
Albi, Musée Toulouse-
Lautrec

**Old Woman sitting on a Bench
at Céleyran (No. 122; detail).**
*Though the drawing is rather
sketchily executed the colour
is applied with great delicacy.*

132

133

134

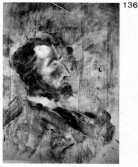
135

136

137

138
139

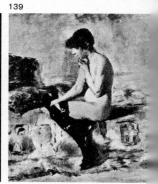

140 Still Life
Canvas/27 × 26/1882
Albi, Musée Toulouse-
Lautrec

141 Horse in its Box
Canvas/54 × 73/1882
Albi, Musée Toulouse-
Lautrec

**142 Landscape with Two
Nudes (*Study for a Tapestry*)**
Canvas/50 × 65/1882
Albi, Musée Toulouse-
Lautrec
There is a sketch of a similar
subject in a private collection

**143 The Old Lady 'of the
Prawns' at Le Bosc**
Canvas/55 × 45/1882
Albi, Musée Toulouse-
Lautrec

144 Head of a Man
Canvas/46 × 38/1882
Albi, Musée Toulouse-
Lautrec
There is another study of a
man's head in this museum

145 Young Routy at Céleyran
Canvas/62 × 51/1882
Albi, Musée Toulouse-
Lautrec

146 An Avenue at Céleyran
Wood/20.1 × 35.1/s.d. 1882
Albi, Musée Toulouse-
Lautrec

**147 The Artist's Mother
reading in the Garden**
Canvas/41 × 32.5/1882
Albi, Musée Toulouse-
Lautrec

*Young Routy at Céleyran
(No. 123; detail).*
*The young man (who also
appears in two more paintings
and eight drawings) is shown
sitting on a wall, whittling a
stick, in a pose reminiscent of
the rustic genre Millet made
popular.*

140

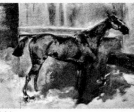

141

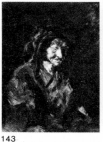
142

143

144

145

146

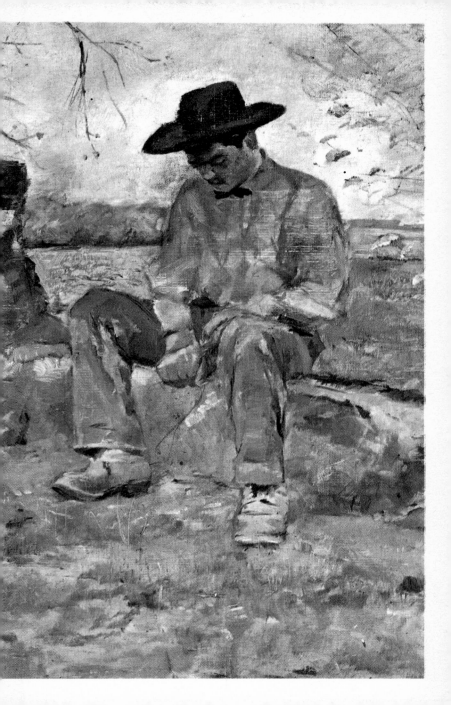

148 Horses and Cart at Céleyran
Canvas/49.7 × 60.9/s.d. 1882
Albi, Musée Toulouse-Lautrec

149 Woman praying
Canvas/75 × 60/s.d. 1882
Private collection

150 Germaine Tapié de Céleyran aged Eight
Canvas/60 × 39.5/s.d. 1882
Paris, private collection

151 Nude Study of a Man
Canvas/65 × 81/red seal/1882
Private collection

152 Rider Seen from behind
Wood/23.5 × 14.5/1882
Paris, private collection

153 The Chief Huntsman
Wood/23.5 × 14/s. 1882
Private collection

154 Portrait of a Little Girl
Wood/23.5 × 16.5/s. 1882
Private collection
On the back: *Nude Woman* (drawing)

155 Jockeys
Canvas/65 × 45/s. 1882
Private collection
There is a similar painting in a private collection in Paris

148

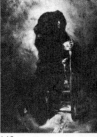
149

151

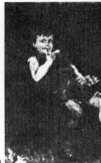
150

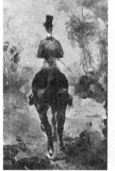
152

154

153

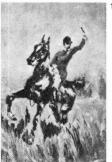

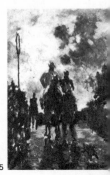
155

48

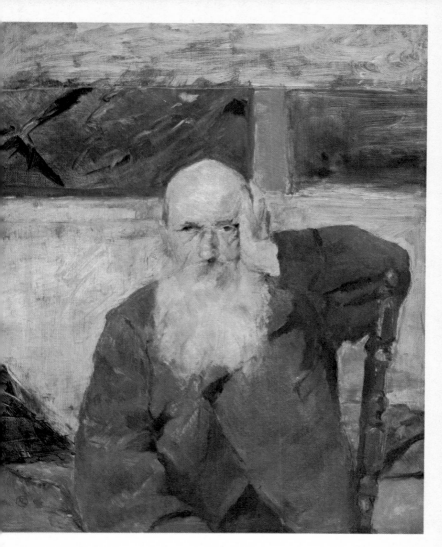

ld Man at Céleyran (No. 125).
e noble old man with flowing white
rd is one of a series of portraits of
nily servants.

156

157

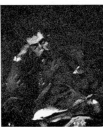

158

160

159

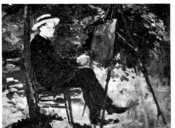

162

*de woman seated on a Divan (No.
9).*

*e first of many nudes by Lautrec. The
icate greys are offset by the pink of
divan.*

An Avenue at Céleyran
(No. 146).
Lautrec painted only a few
landscapes, mainly views of
the estates at Céleyran and Le
Bosc.

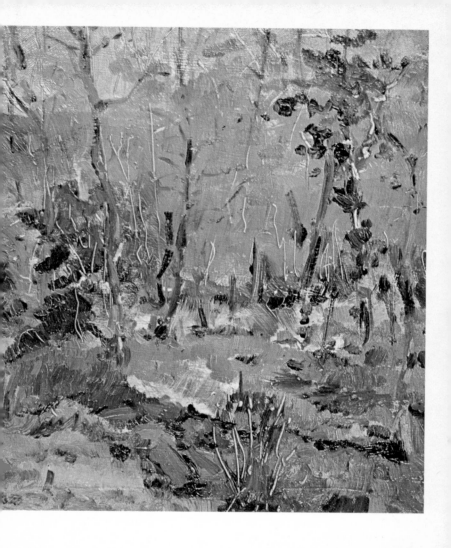

164 Head of a Man
Canvas/30 × 25/1883
Private collection

165 Study of a Nude Woman
Canvas/25 × 30/1883
Private collection

166 Allegory: The Springtime of Life
Canvas/55 × 42/red seal/1883
Albi, Musée Toulouse-Lautrec
There is a painting of the same subject in a private collection

167 Nude Study of a Man
Cardboard/60.7 × 46/1883
Private collection
There are four similar nude studies in the Musée Toulouse-Lautrec, Albi, and one in a private collection in Paris

168 Nude Study of a Man
Canvas/80 × 64/red seal/1883
Amsterdam, Van Wisselingh Collection
There are two similar works in private collections in Paris and Switzerland

169 Ploughing in the Vineyard
Canvas/56 × 46/1883
Private collection

170 Seated Woman
Wood/47 × 27.8/1883
Albi, Musée Toulouse-Lautrec

171 Allegory: A Rape
Canvas/72.8 × 53.8/1883
Albi, Musée Toulouse-Lautrec
There are two more sketches of allegorical and mythological subjects in this museum

172 Merovingian Scene
Canvas/55.4 × 37.7/s. 1883
Albi, Musée Toulouse-Lautrec

173 Scene from Prehistory
Cardboard/48 × 62/1883
Albi, Musée Toulouse-Lautrec

174 Pollaiolo's 'Bust of a Warrior'
Canvas/61 × 50/s. 1883
Albi, Musée Toulouse-Lautrec

164

165

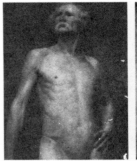
166

170

167

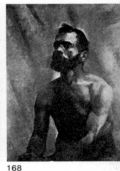
168

169

171

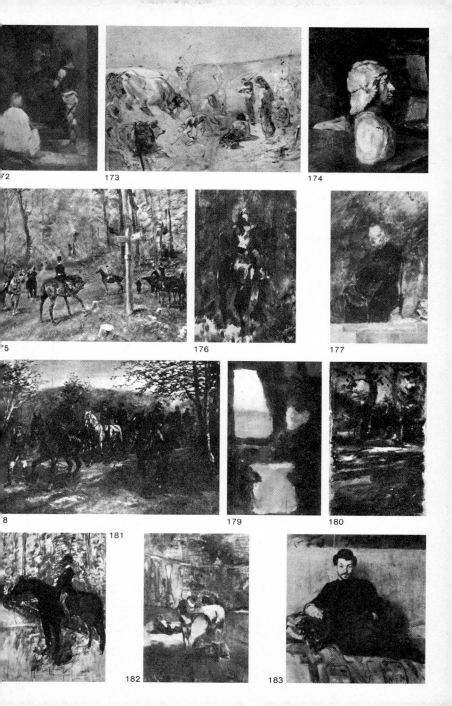

172

173

174

5

176

177

8

179

180

181

182

183

175 Crossroads in the Forest
Canvas/49 × 60/s.d. 1883
Private collection

176 Cuirassier on Horseback Seen from behind
Wood/25.5 × 16.6/s.d. 1883
Paris, private collection

177 A Monk
Canvas/40.5 × 32.5/s.d. 1883
Albi, Musée Toulouse-Lautrec

178 Returning from the Hunt
Canvas/94 × 137/s. 1883
Private collection

179 In a Railway Carriage
Wood/22.4 × 14.1/1883
Albi, Musée Toulouse-Lautrec

180 Undergrowth at Malromé
Wood/16.5 × 10.2/c. 1883
Private collection

181 The Artist's Father out riding
Canvas/92 × 65/c. 1883
Private collection

182 A Spartan showing his Son a Drunken Helot
Wood/22 × 16/c. 1883
Private collection

183 Monsieur Dennery
Canvas/55 × 46.5/s. c. 1883
USA, private collection

Horses and Cart at Céleyran (No. 148).
Lautrec was drawn to scenes of working life on the estate since he was unable to join the rest of his family out hunting.

184 Road at Malromé
Wood/17 × 10.4/c. 1883
Paris, Fabre Collection
There is another sketch for a
view of Malromé in a private
collection

185 A Landing-stage
Wood/14.2 × 23.5/1883
Private collection
On the back: *Anchors*

186 Rider out hunting
Wood/16.5 × 24/1884
Paris, Dagieu-Sully
Collection

**187 Fat Maria (*Vénus de
Montmartre*)**
Canvas/79 × 64/1884
Wuppertal, Von der Heydt
Museum

188 Trap Stuck in the Mud
Wood/16.5 × 24/s. 1884
Private collection

189 Jeanne
Canvas/64 × 55.5/1884
Otterlo, Rijksmuseum
Kröller-Müller

**190 The Sacred Grove
(*Parody of Puvis de
Chavannes*)**
Canvas/172 × 380/1884
New York, Pearlman
Collection

191 Undergrowth
Canvas/40.5 × 27/c. 1884
Béziers, Vic Collection

**Huntsman and Woodcutter
(*No. 160*).**
*This painting shows the
huntsman whose job it was to
find game and drive it from its
cover.*

184

185

186

191

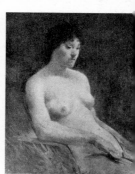

188

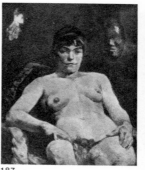

187

189

19

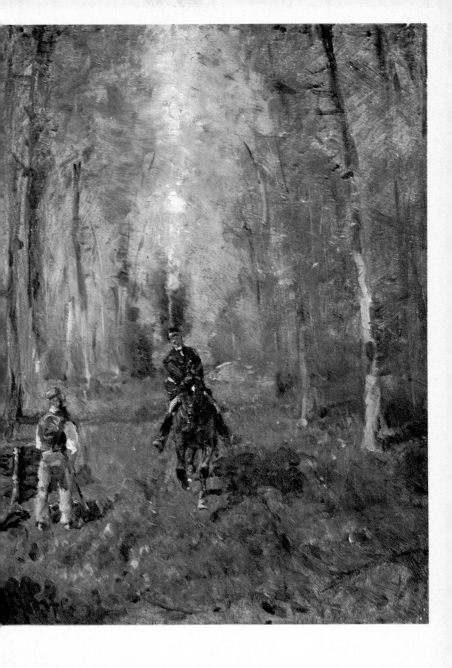

192 Coffee Pot
Wood/24 × 17/*c.* 1884
Lyons, Gontard Collection

193 Self-portrait from behind
Canvas/51 × 43/red seal/
c. 1884
Paris, Cligman Collection

194 Stage-manager in the Wings
Wood/118 × 70/1885
Zurich, Bührle Collection

195 Ballerina in her Dressing-room
Transferred from plaster to canvas/115 × 101/1885
New York, private collection

196 The Ballet
Transferred from plaster to canvas/150 × 150/1885
Chicago, Art Institute (Helen Birch Bartlett Memorial Collection)

197 In the Gods
Wood/245 × 101/1885
Paris, private collection

198 Carmen
Canvas/52.8 × 41/1885
Williamstown (USA), Sterling and Francine Clark Art Institute

192

193

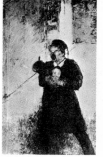
194

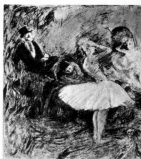
195

196

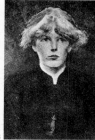
198

197

Carmen (No. 198).
Lautrec was attracted by the painter Rachou's red-haired model and portrayed her strong expressive features in many of his paintings.

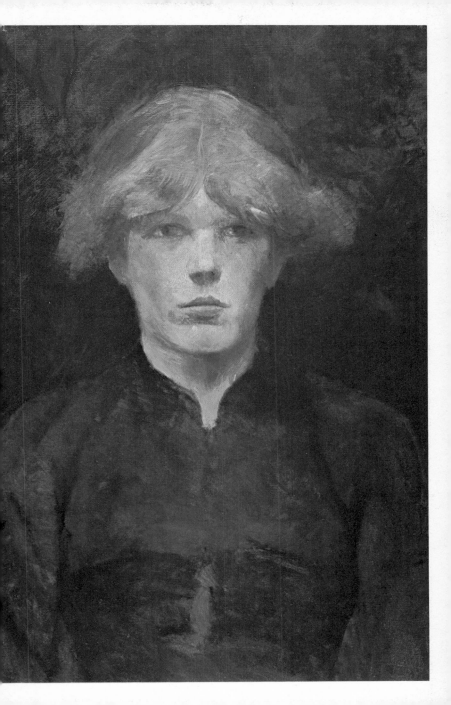

199 Carmen
Wood/24 × 15/1885
New York, Mellon Bruce
Collection

200 Red-haired Carmen
Wood/23.9 × 15/1885
Albi, Musée Toulouse-
Lautrec
On the back: *Carmen with
Bowed Head*

201 The Washerwoman
Wood/24 × 16.1/1885
Albi, Musée Toulouse-
Lautrec
On the back: *At the Water's
Edge* 1880

**202 Dancer seated on a Pink
Divan**
Canvas/47.5 × 36/1885
Private collection

**203 Portrait of Suzanne
Valadon**
Canvas/55 × 45/s. 1885
Private collection

**204 Portrait of Suzanne
Valadon**
Canvas/54.5 × 45/s. 1885
Copenhagen, Ny Carlsberg
Glyptotek

205 In the Studio
Canvas/140 × 55/red seal/
1885
Private collection

**206 Portrait of the Painter
René Grenier**
Cardboard/46 × 28/s. 1885
Private collection

207 Portrait of Lily Grenier
Cardboard/50 × 40/1885
Chicago, Art Institute (given
by Carter H. Harrison)

**Woman with the Pink Bow
(No. 217).**
*The sitter, Jeanne Wenz, was
the wife of Frederic Wenz, one
of Lautrec's painter friends.
Before he had his own studio
he used to work in those of his
friends and share their models.*

199

200

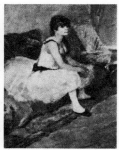

201

203 204

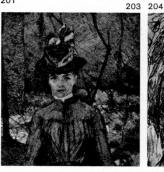

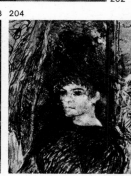
202

205 206 2

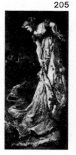

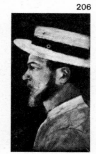

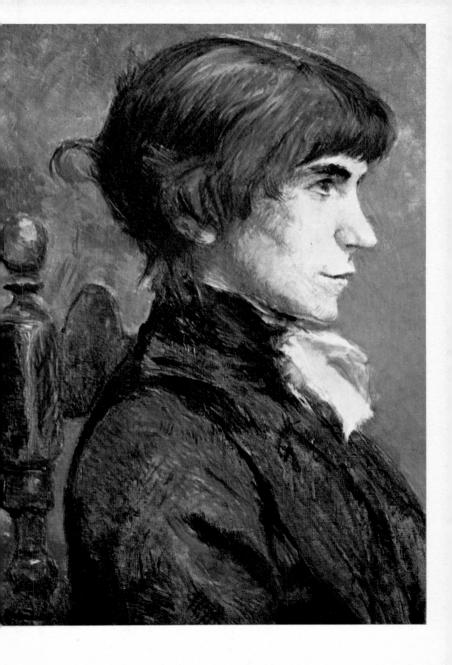

208 Man lighting a Cigar
Paper/65 × 49/red seal/1885
Albi, Musée Toulouse-
Lautrec

209 Young Woman
Canvas/82 × 63/1885
Belgrade, Národní Múzej

210 Dancer in the Wings
Canvas/80 × 65/s. 1885
Private collection

*211 Portrait of the Painter
Emile Bernard*
Canvas/54.5 × 43.5/1885
London, Tate Gallery

212 Carmen
Canvas/27 × 22/1885
Sacher Collection

*213 The Refrain of the Louis
XIII Chair at the Mirliton*
Paper on canvas/78.5 × 52/s.
1886
New York, Metropolitan
Museum of Art (Milton de
Groot bequest)

*214 The Quadrille of the Louis
XIII Chair at the Elysée
Montmartre*
Canvas/45 × 56/s. 1886
Private collection

208
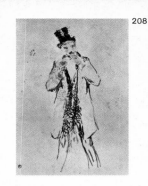

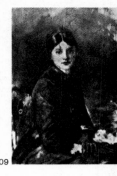
209

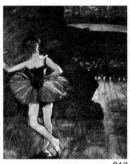

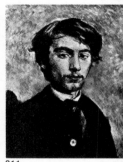

210
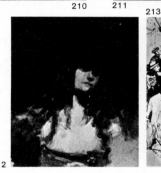
211

213

212
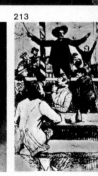

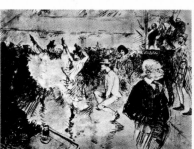
214

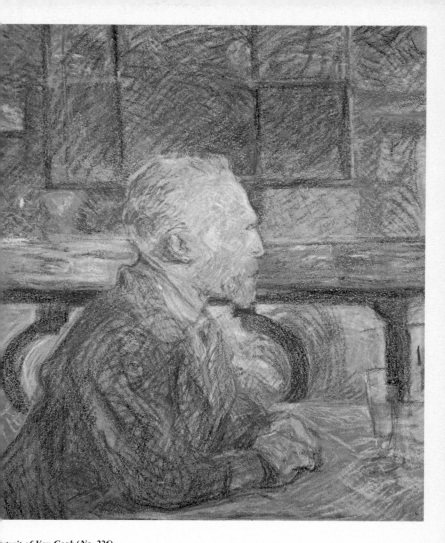

***trait of Van Gogh** (No. 226).*
e two painters met at Cormon's
dio. Here Van Gogh worked for a
e after coming to Paris at the
gestion of his brother Théo, an art
ler at a Goupil gallery who was
ceeded there by Maurice Joyant.

215 The Ballet
Canvas/44 × 86/s. 1886
Private collection

216 The Ballet
Canvas/100 × 152/s. 1886
Stockholm, Thielska Galleriet

217 Woman with the Pink Bow (Jeanne Wenz in profile)
Canvas/80 × 58/s. 1886
Chicago, Art Institute
(Coburn gift)

218 Portrait of an Old Man
Wood/24 × 17/1886
Private collection
On the back: *Portrait of an Old Man in profile*

219 At the Washerwoman's
Canvas/40 × 30/red seal/1886
Private collection

220 Artilleryman and Woman
Canvas/70 × 48/red seal/1886
Albi, Musée Toulouse-Lautrec
There are four more paintings of the same subject in this museum

221 Portrait of an Old Man
Wood/32 × 26.5/s. 1886
Private collection
There is a similar portrait of a man (1888) in a private collection

222 At the Cafe
Canvas/61 × 50/1886
Holland, private collection

223 'A Saint-Lazare'
Cardboard/68 × 52/s. 1886
Private collection

Portrait of Lily Grenier (No. 248).
Lautrec painted several portraits of Lily, wife of the painter Grenier. The couple were close friends of the young artist, who lodged with them for several months.

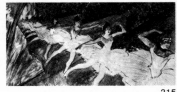

215

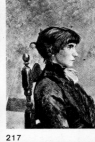

217

216

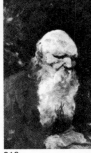

218

219

223

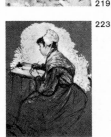

220

221 222

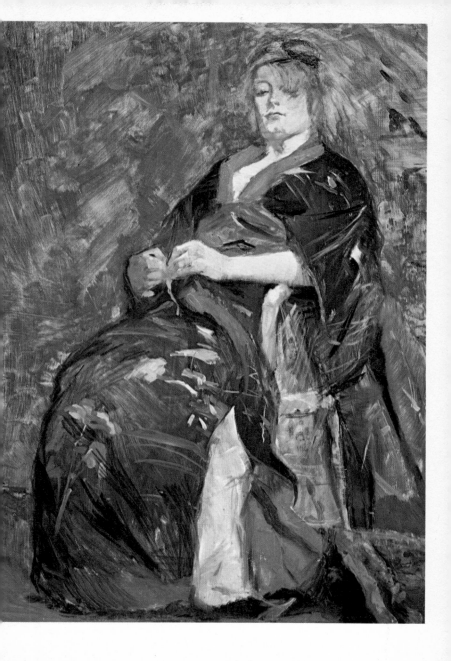

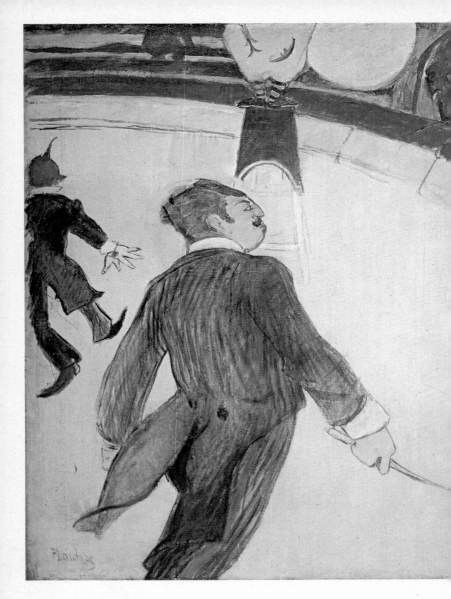

At the Cirque Fernando:
Équestrienne (No. 258).
Like Degas and Seurat
Lautrec loved the circus.

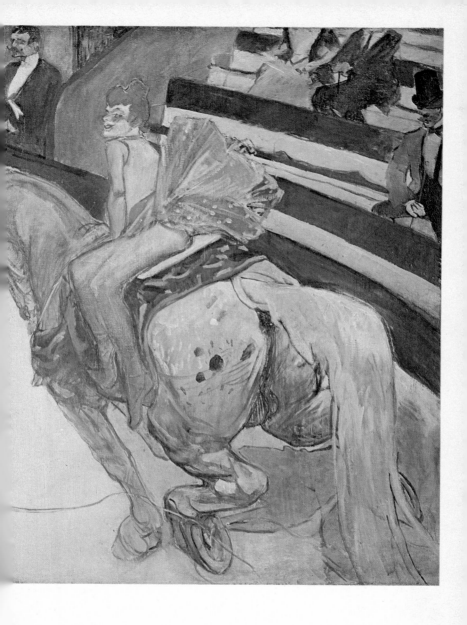

224 Portrait of the Painter François Gauzi
Canvas/47.5 × 37.5/1887
Zurich, Bührle Collection

225 The Artist's Mother
Canvas/54 × 45/s. 1887
Albi, Musée Toulouse-Lautrec

226 Portrait of Van Gogh
Pastel on cardboard/
57 × 46.5/1887
Amsterdam, Rijksmuseum
Vincent van Gogh

227 Portrait of Mme Juliette Pascal
Canvas/53 × 43/s. 1887
Cannes, Jay Gould Collection

228 Portrait of Mme Aline Gilbert
Canvas/61 × 50/1887
New York, French Art Galleries

229 At the Moulin de la Galette
Cardboard/61 × 50/red seal/
1887
Private collection

230 La Goulue and Valentin-le-Désossé at the Moulin de la Galette
Cardboard/52 × 39.2/red seal/
1887
Albi, Musée Toulouse-Lautrec

231 At the Moulin de la Galette
Cardboard/55 × 46/red seal/
1887
USA, private collection

224 225

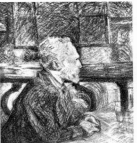

226 227

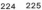
228

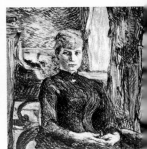

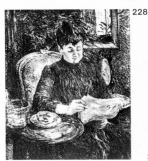

229

230

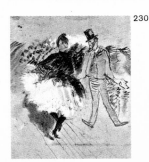

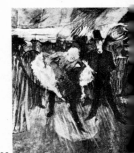

231

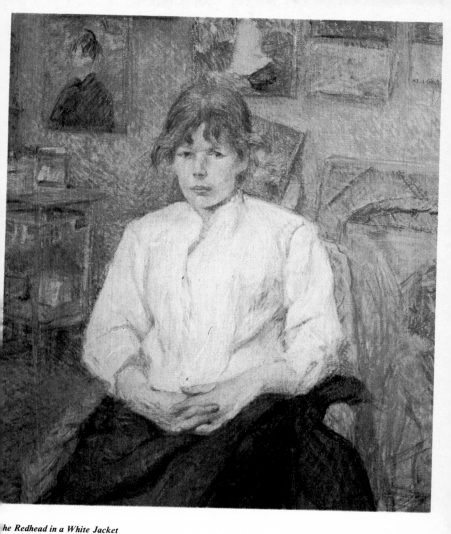

**he Redhead in a White Jacket
No. 263).**
*he model is once more Carmen Gaudin,
r flaming red hair set off by the white
her blouse.*

232 The Masked Ball at the Elysée-Montmartre
Cardboard/56 × 44/red seal/1887
Switzerland, private collection

233 At the Elysée-Montmartre
Paper on canvas/81 × 65/red seal/1887
Albi, Musée Toulouse-Lautrec

234 Four People at Table
Canvas/50 × 81/red seal/1887
Private collection

235 At the Bar
Canvas/55 × 42/red seal/1887
Upperville (USA), Mellon Collection

236 Bust-portrait of a Woman in profile
Canvas/56 × 41/red seal/1887
Private collection

237 Profile of a Dancer standing
Paper/57 × 45/red seal/1887
Albi, Musée Toulouse-Lautrec

238 Portrait of Louis Pascal
Canvas/61 × 50/1887
Paris, private collection

239 Masked Ball
Paper/50 × 65/red seal/1888
Albi, Musée Toulouse-Lautrec

Studio Model: Hélène Vary (No. 266).
Hélène Vary was one of Lautrec's neighbours. He knew her as a child and she posed for him several times when she was seventeen.

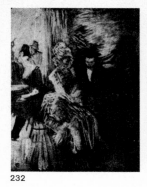

232

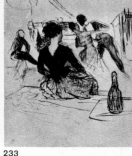

233

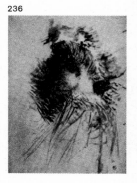

234

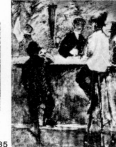

236

235

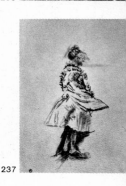

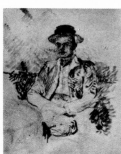

237

238

23

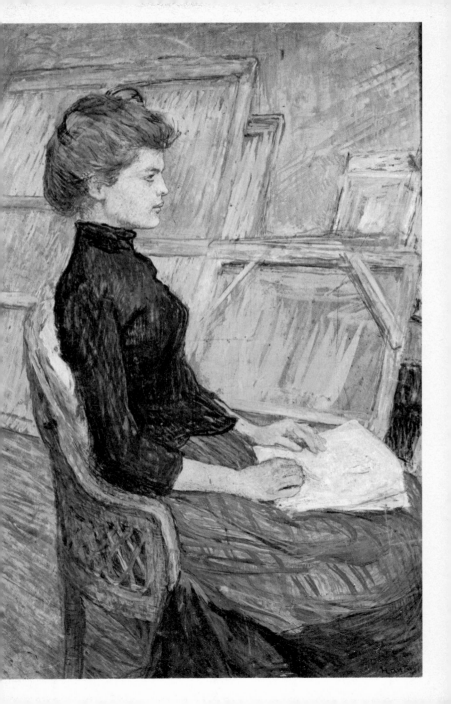

240 Man in a Shirt
Paper/65 × 49/red seal/1888
Albi, Musée Toulouse-
Lautrec

241 Woman standing
Paper/62 × 48/red seal/1888
Albi, Musée Toulouse-
Lautrec

242 Portrait of a Woman
Canvas/29 × 22/1888
Private collection

**243 Portrait of the Painter
Francois Gauzi**
Canvas/78.5 × 39/1888
Toulouse, Musée des
Augustins

244 First Communion Day
Cardboard/63 × 36/s. 1888
Toulouse, Musée des
Augustins

**245 Riders in the Bois de
Boulogne**
Cardboard/84 × 52.5/s. 1888
New York, private collection

**246 The Trace-horse of the
Omnibus Company**
Cardboard/80 × 51/s. 1888
Paris, private collection

247 Masked Ball
Canvas/65 × 60/s.d. 1888
Los Angeles, private
collection
There is a study on cardboard
(1887) in a private collection

**248 Portrait of Lily Grenier in
an Armchair (or in a garden)**
Canvas/55.5 × 46.5/1888
New York, private collection

240

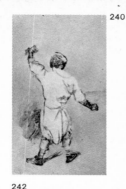
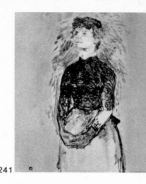

241

242

243

244

245

2

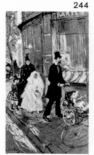
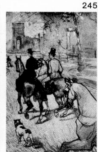
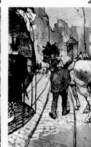

247

248

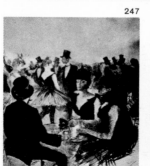
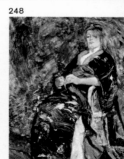

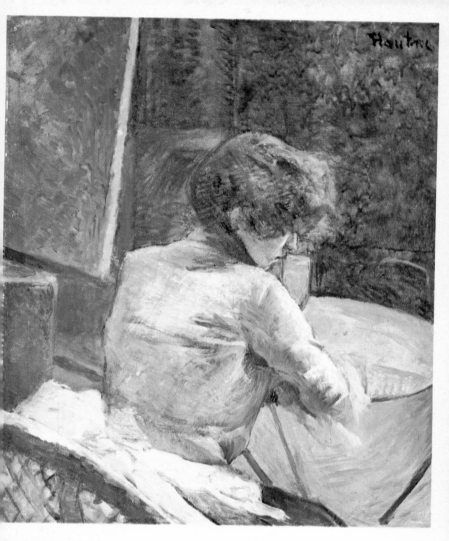

A Grenelle' (No. 273).

*...autrec was a perceptive observer of his
...male models. The woman's mood in
...is painting is expressed not by her face,
...hich is scarcely visible, but by her
...osture of weary resignation.*

75

249 Portrait of Lily Grenier
Canvas/55 × 45/1888
USA, private collection

250 Portrait of the Painter René Grenier
Wood/34 × 26/1888
New York, private collection

251 'A Montrouge' ('Rosa la Rouge')
Canvas/70 × 47/s. 1888
Merion (USA), Barnes Foundation

252 'A Batignolles'
Canvas/92 × 65/1888
London, private collection

253 'A la Bastille' (Jeanne Wenz)
Canvas/72 × 49/s. 1888
Upperville (USA), Mellon Collection

254 'A Grenelle' (Absinthe Drinker)
Canvas/55 × 45.8/s. 1888
New York, private collection

255 A Dancer
Canvas/55 × 46/1888
Switzerland, private collection

256 The Spanish Dancer
Canvas/55 × 40/1888
Private collection

249

250

251
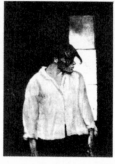

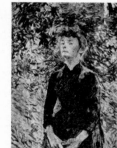
252

253
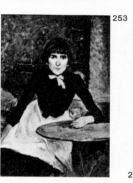

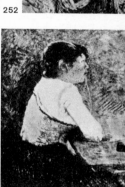
254

255　256

76

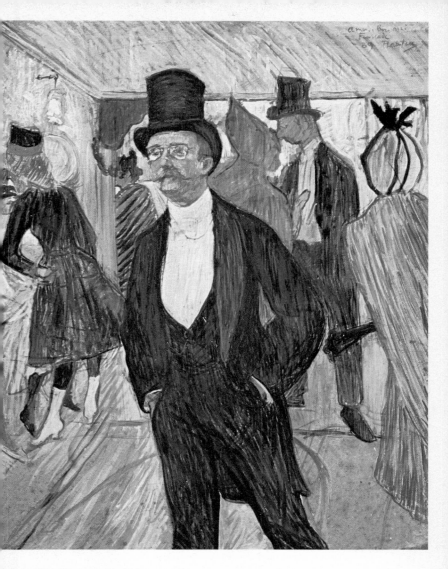

Portrait of Henri Fourcade (No. 276).
The subject of this painting identified by the inscription 'A mon bon ami Fourcade 89 H T Lautrec', *was a banker and, like Lautrec, obviously an habitué of Parisian night-life.*

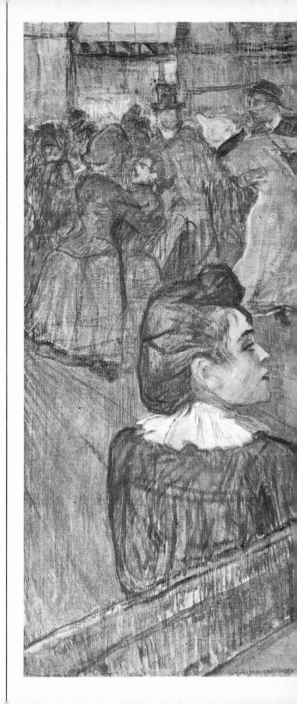

***At the Moulin de la Galette
(No. 280).***
*The man on the right, seen in
profile, is the painter Joseph
Albert. The drawing for this
work appeared in the*
COURRIER FRANÇAIS.

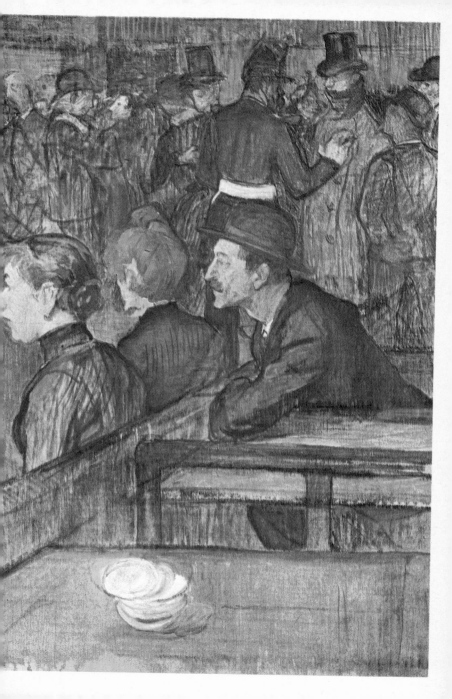

257 At the Elysée-Montmartre
Canvas/73 × 51/1888
Private collection

**258 At the Cirque Fernando:
Équestrienne**
Canvas/98 × 161/s. 1888
Chicago, Art Institute

**259 At the Cirque Fernando:
Clown**
Canvas/85 × 47/red seal/1888
Private collection

**260 At the Cirque Fernando:
Clown**
Canvas/115 × 42/red seal/
1888
France, private collection

261 At the Cirque Fernando
Canvas/61 × 81/s. 1888
Buenos Aires, Santa Marina
Collection

**262 At the Cirque Fernando:
Équestrienne**
Painted on the skin of a
tambourine/diameter 26 cm/
s. 1888
New York, Payson Collection

**263 The Redhead in a White
Jacket**
Canvas/55.9 × 45.7/s. 1888
Boston, Museum of Fine Arts

**264 Studio Model: Hélène
Vary**
Cardboard/34.8 × 19.5/red
seal/1888
Albi, Musée Toulouse-
Lautrec

265 Hélène Vary reading
Cardboard/73 × 52/s. 1888
Private collection

**266 Studio Model: Hélène
Vary**
Cardboard/75 × 50/s. 1888
Bremen, Kunsthalle

At the Moulin de la Galette
(No. 280; detail).

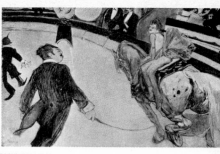

257

259 260

263

262

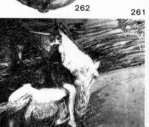

261

264 265

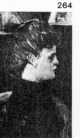

266

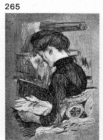

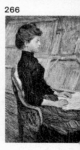

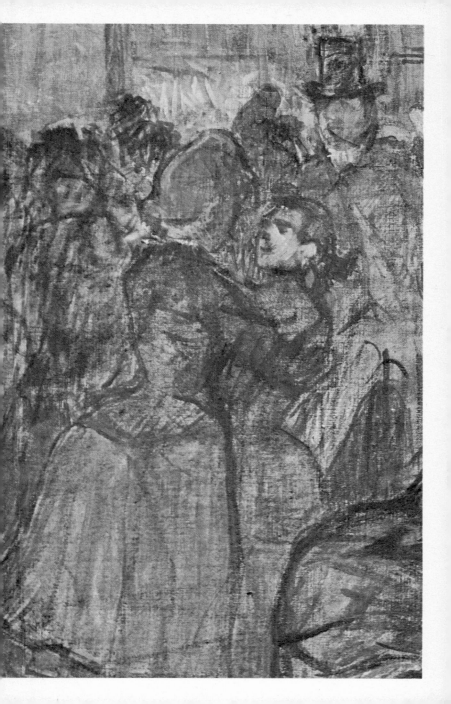

267 At the Circus: in the Wings
Canvas/67 × 60/s. 1888
Newark (USA), Newark Museum

268 Equestrienne
Paper/89 × 71/red seal/1888
Private collection

269 A Little Dog
Canvas/33 × 41/1888
Private collection
There is another version of the same subject in a private collection

270 Young Nude Woman
Canvas/46 × 38/c. 1888
Haarlem, Koenigs Collection

271 Dancer
Canvas/81 × 59.5/c. 1888
New York, private collection

272 Clown
Cardboard/35 × 32/s. c. 1888
Private collection

273 'A Grenelle'
Canvas/56 × 46.8/s. c. 1888
Williamstown (USA), Sterling and Francine Clark Art Institute

274 Portrait of Frederic Wenz
Canvas/55 × 46/s. c. 1888
USA, private collection

The Morning After (No. 284; detail).
Suzanne Valadon (mother of Maurice Utrillo, born 1883) posed for this painting. The drawing for it was also published in the COURRIER FRANÇAIS.

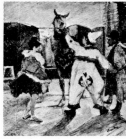
267

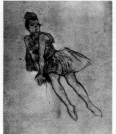
268

269

270
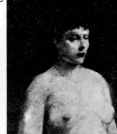

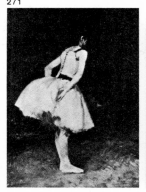
271

272
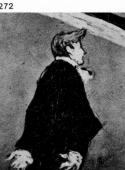

273

274

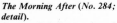

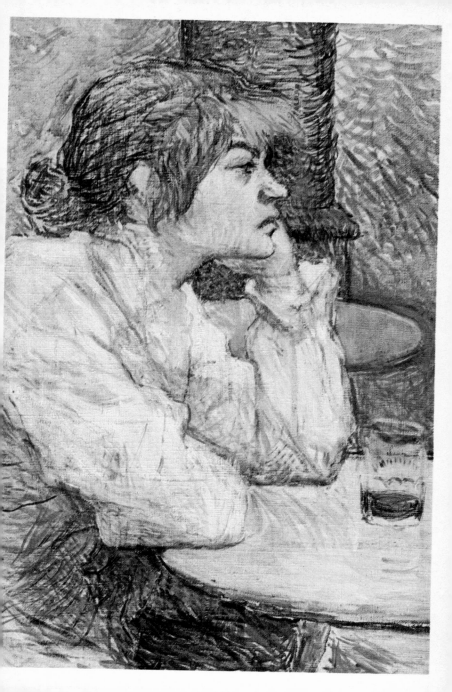

275

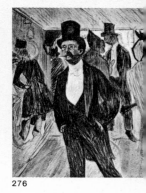
276

277
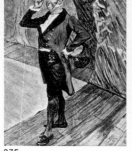

2

279

280

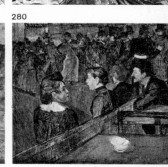
281

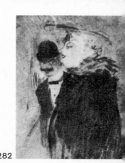
282

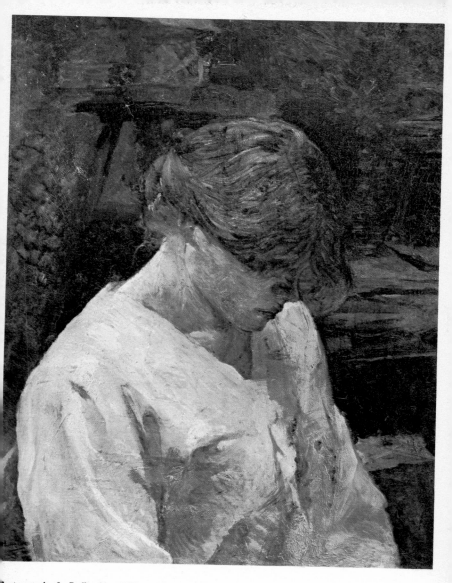

Bust-portrait of a Redhead in a White Jacket (No. 289).
The model is Carmen Gaudin. She is shown with her hair falling across her face, in Forest's garden.

283 Woman at her Toilet
(*'Gueule de Bois'*)
Cardboard/55 × 46/1889
Albi, Musée Toulouse-
Lautrec

284 The Morning After
(*'Gueule de Bois'*)
Canvas/47 × 55/s. 1889
Cambridge (USA), Fogg Art
Museum, Harvard University
There is a pastel sketch in the
Musée Toulouse-Lautrec,
Albi

**285 Woman with an Umbrella
in Forest's Garden**
Cardboard/69.2 × 69.2/s. 1889
New York, Salz Collection

286 Profile of a Redhead
Cardboard/71 × 58/s. 1889
Upperville (USA), Mellon
Collection

**287 Redhead sitting in Forest's
Garden**
Canvas/64.6 × 53.7/s. 1889
New York, private collection

**288 Bust-portrait of a Woman
in Forest's Garden**
Canvas/55 × 46/s. 1889
New York, Payson Collection

**289 Bust-portrait of a
Redhead in a White Jacket,**
Canvas/58.2 × 47.5/s. 1889
Private collection

290 The Washerwoman
Canvas/93 × 75/red seal/1889
Private collection

*Mlle Dihau playing the Piano
(No. 302).*
*Lautrec was very friendly with
the Dihaus, a family of
musicians whom Degas also
painted. As a young artist
Lautrec used to visit their
house to admire the older
painter's work.*

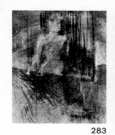

283

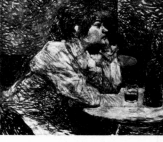

284

285

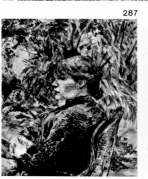

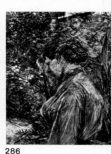

286

287 288

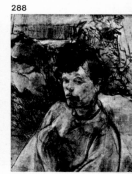

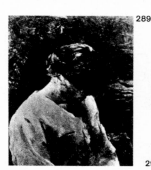

289

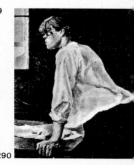

290

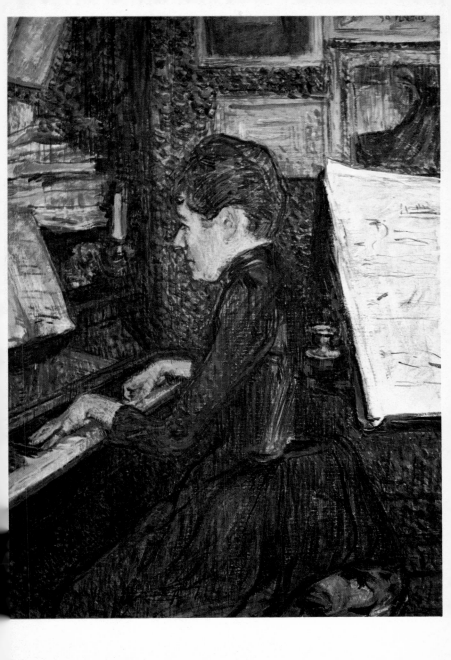

291 Woman at her Toilet
Cardboard/45 × 54/s. 1889
Private collection

292 Face-powder
Cardboard/65 × 58/s. 1889
Amsterdam, Rijksmuseum
Vincent van Gogh

293 Woman reading
Cardboard/68 × 61/s. 1889
Brussels, private collection

294 Blaco, Forest's Dog
Cardboard/35 × 25/s. 1889
Paris, private collection

295 Woman at a Window
Cardboard/71 × 47/s.d. 1889
Moscow, Pushkin Museum

296 Profile of the Redhead
Canvas/74 × 50/s. 1889
USA, Ford Collection

297 The Redhead
Canvas/55.5 × 50/s. *c.* 1889
Zurich, Bührle Collection

298 The Box
Canvas/38 × 28/*c.* 1889
USA, private collection

299 Head of a Woman
Wood/23.9 × 16.6/1890
Albi, Musée Toulouse-
Lautrec
On the back: **Undergrowth
and Fencing** 1880

Gabrielle the Dancer
(No. 303; detail).
*This model also posed for
Lautrec at the luxurious
brothel in Rue de Moulins and
with Cha-u-Kao at the Moulin
Rouge.*

**The Dance at the Moulin
Rouge (No. 305).** (pp. 90–91)
*This is the first of Lautrec's
paintings in which Jane Avril
appears, seen full face between
Valentin-le-Désossé and his
partner. The group in the
background, to the right of the
waiter, are Lautrec's friends,
Varney, Maurice Guibert,
Paul Sescau and François
Gauzi.*

88

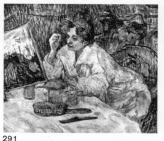
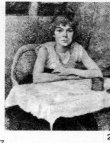

291

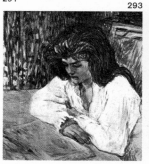
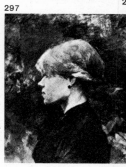

293 297 2

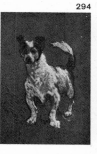
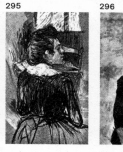
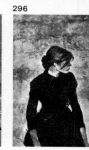

294 295 296

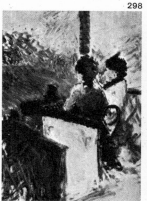
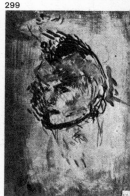

298 299

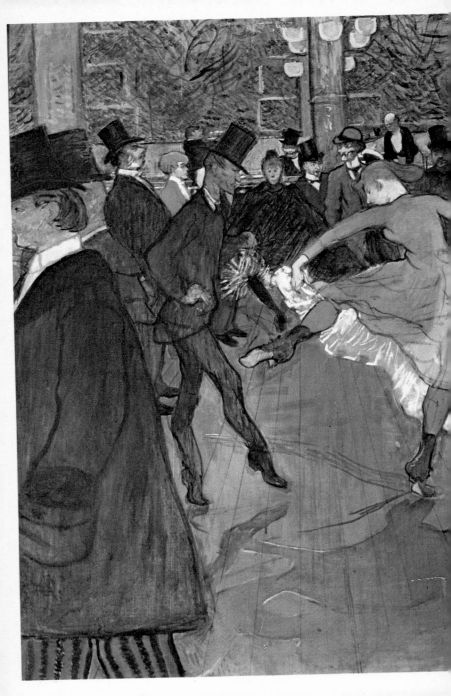

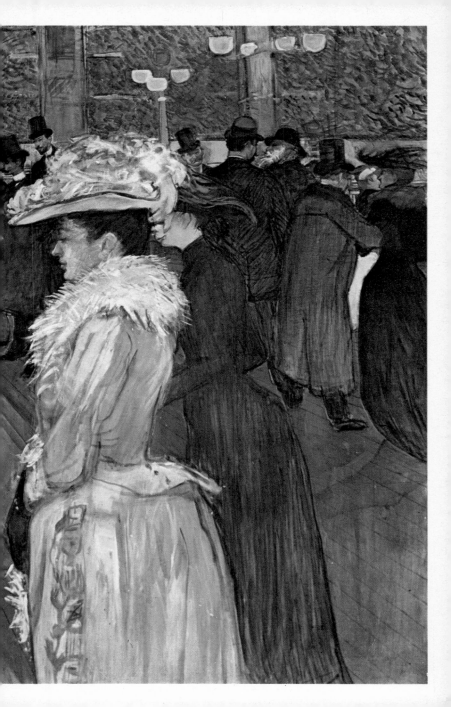

300 Woman smoking a Cigarette
Cardboard/80 × 60/1890
Albi, Musée Toulouse-Lautrec

301 The Little Dog Follette
Cardboard/55 × 30/s.d. 1890
Philadelphia, Museum of Art

302 Mlle Dihau playing the Piano
Cardboard/63 × 48/s.d. 1890
Albi, Musée Toulouse-Lautrec

303 Gabrielle the Dancer
Cardboard/55 × 40/s. 1890
Albi, Musée Toulouse-Lautrec

304 Berthe la Sourde in Forest's Garden
Cardboard/75 × 58/s. 1890
Private collection

305 The Dance at the Moulin Rouge
Canvas/115 × 150/s.d. 1890
Philadelphia, McIlhenny Collection

306 Woman smoking a Cigarette
Cardboard/47 × 30/s.d. 1890
New York, Brooklyn Museum

307 The Cocker Spaniel Tommy
Cardboard/42 × 57/s. 1890
Paris, Niarchos Collection

308 Seated Woman facing left
Cardboard/73 × 40.6/s. 1890
New York, private collection

Portrait of Augusta (No. 311). The firm lines of the nose and the decisive mouth give this soft, quiet woman's face its character.

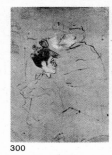
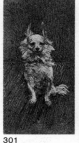
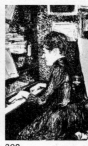

300

301

302

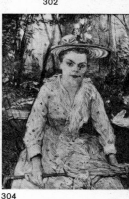

303

304

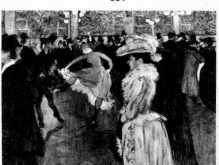

305

306

308

307

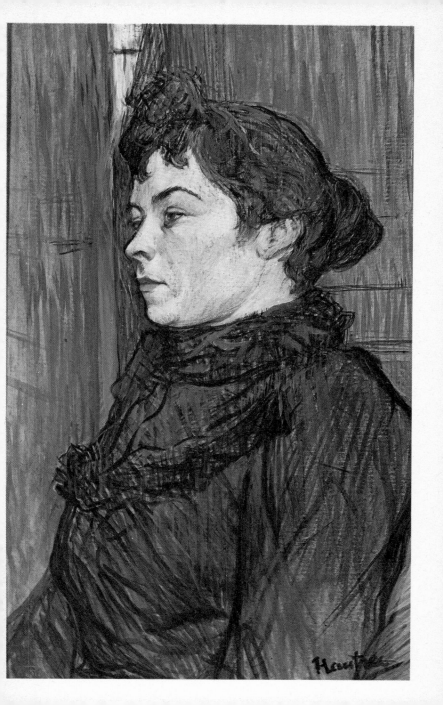

309 'En Meuble' (The Letter)
Cardboard/48 × 54/1890
Private collection

310 Redhead Seated in Forest's Garden
Cardboard/50 × 32/s. 1890
Birmingham, Barber Institute of Fine Arts

311 Portrait of Augusta
Cardboard/59 × 37.5/s. 1890
Cambridge (USA), Fogg Art Museum, Harvard University

312 The Policeman's Daughter
Cardboard/67 × 50/s. 1890
Hamburg, Kunstmuseum

313 Trapezist
Cardboard/68 × 52/1890
Albi, Musée Toulouse-Lautrec

314 Seated Dancer
Cardboard/57.5 × 46.7/s. 1890
USA, private collection

315 Her First Pair of Tights
Cardboard/59 × 46/s. 1890
Berne, private collection

316 Trapezist from the Cirque Fernando
Cardboard/69 × 46/s. 1890
Private collection

317 Berthe la Sourde in the Studio
Cardboard/62 × 45/s.d. 1890
Private collection

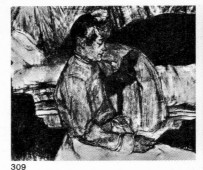

309

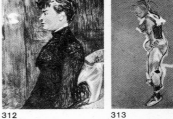

310

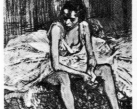

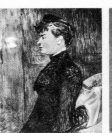

311

312

313

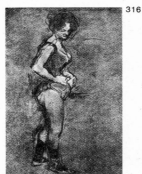

314

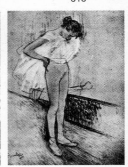

315

316

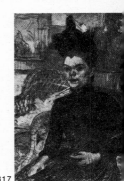

317

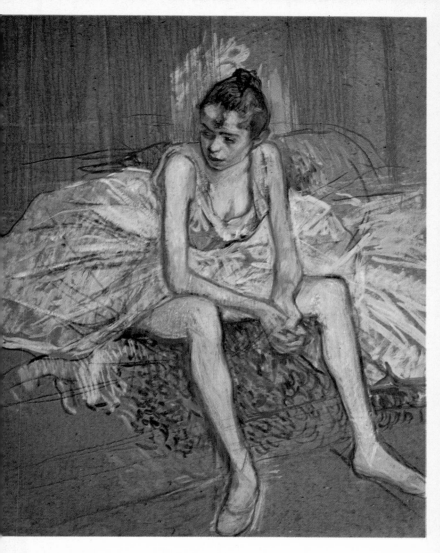

ated Dancer (No. 314).
e theme and style of this painting
ow Lautrec's admiration for Degas
d the affinity between the two painters.

Photocredits
Albi, Musée Toulouse-
Lautrec: pp. 11; 13; 15; 17;
19; 21; 27; 29; 35; 41; 43;
45; 51; 53; 56/57; 89. Boston,
Museum of Fine Arts: p. 71.
Cambridge (USA), Fogg Art
Museum: pp. 83; 93.
Chicago, Art Institute: p. 63.
Giraudon: pp. 38/39.
Rizzoli: pp. 25; 31; 33; 47; 49;
59; 61; 65; 67; 68/69; 73; 77;
78/79; 81; 85; 87; 90/91; 95.
Williamstown, Sterling and
Francine Clark Institute:
p. 75.

See volume II for Bibliography

First published in the United States of America 1981
by Rizzoli International Publications, Inc.
712 Fifth Avenue, New York, New York 10019
Copyright © Rizzoli Editore 1979
This translation copyright © Granada Publishing 1980
ISBN 0-8478-0363-5
LC 80-54043
Printed in Italy